IMAGES
of Rail

SOUTHERN PACIFIC
IN CALIFORNIA

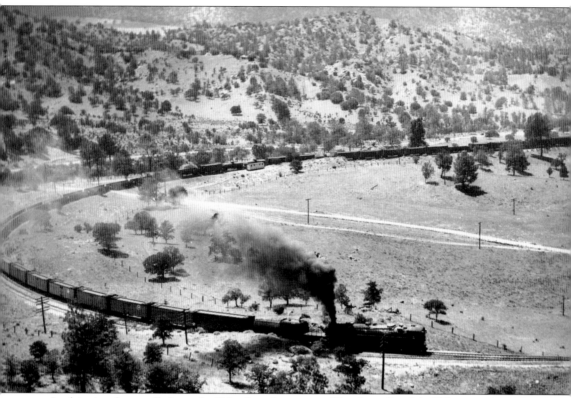

In this view from well above the Tehachapi loop, one of Southern Pacific's (SP) iconic Articulated Consolidations (AC) pulls a long line of refrigerator cars eastbound past Walong siding in the Tehachapi loop. The siding, crucial for the ability to allow trains running in opposing directions to pass one another, was named in honor of W. A. Long, Southern Pacific's roadmaster for the district at the time of construction. The flat front on the AC locomotive and the wood siding on the reefers are hints this photograph was taken before World War II. The Southern Pacific's route down the San Joaquin Valley toward Los Angeles originally ended a bit south of Bakersfield. The rugged Tehachapis were considered uncrossable because of steep grades until engineers Austin De Wint Foote and William Hood devised the loop in 1876. The loop makes maximum benefit of minimum space by allowing the climb up the Tehachapis to be kept at a reasonable grade. A train just over 0.75 miles long will pass over itself. (Southern Pacific photograph, Paul C. Koehler Collection.)

ON THE COVER: Southern Pacific's gleaming and glamorous red, orange, and black color scheme was introduced for its streamlined Daylight passenger trains in the late 1930s, and soon came to represent style and luxury in the flamboyant California manner. It was symbolic of the golden age in American passenger railroading, yet symbolic also of the beginning of the end for the great-name trains. At the time the livery was introduced, Douglas DC-3s were carrying passengers across the continent. By the time SP's *Shasta Daylight* was passing beneath its namesake Mt. Shasta en route from Portland to Sacramento and Oakland, Boeing 707 and Douglas DC-8 jet planes would soon rewrite the definition of high-class travel. The picture dates from the early days of the *Shasta Daylight*, the early 1950s, when General Motors E-units pulled the train. Although handsome, the E-units did not have enough tractive effort for the mountain grades, and Alco PA and PB units were substituted. (Southern Pacific photograph, Paul C. Koehler Collection.)

Images of Rail
Southern Pacific in California

Kerry Sullivan

ARCADIA
PUBLISHING

Copyright © 2010 by Kerry Sullivan
ISBN 978-0-7385-8207-8

Published by Arcadia Publishing
Charleston, South Carolina

Printed in the United States of America

Library of Congress Control Number: 2010934599

For all general information, please contact Arcadia Publishing:
Telephone 843-853-2070
Fax 843-853-0044
E-mail sales@arcadiapublishing.com
For customer service and orders:
Toll-Free 1-888-313-2665

Visit us on the Internet at www.arcadiapublishing.com

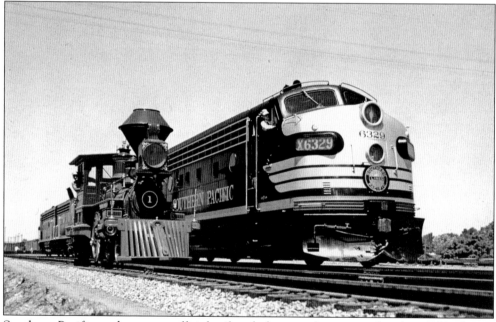

Southern Pacific made sure an official railroad photographer was on hand in 1950 when it showcased its newest locomotives with its oldest. Southern Pacific No. 1, the C. P. *Huntington*, and Southern Pacific No. 6329 stand at opposite ends of motive power technology developed during more than 80 years of railroad history. Danforth, Cooke and Company in New Jersey built the *Huntington*. It was delivered by sailing ship after a six-month, 19,000-mile voyage around Cape Horn. No. 1 was used during construction of the transcontinental railroad in the 1860s. The 6329 is part of a four-unit consist of Electro-Motive Division 1,500-horsepower F-7 units, adding up to 6,000 horsepower transmitted through 16 traction motors. Like its tiny predecessor, 6329 and its companions would serve on "The Hill," Southern Pacific's Overland Route across the High Sierra. (Southern Pacific photograph, Paul C. Koehler Collection.)

CONTENTS

Acknowledgments		6
Introduction		7
1.	The Southern Pacific: A Mountain Railroad	9
2.	Trains to San Francisco Bay	25
3.	The Green and Gold Coast Line	37
4.	The Valley, the Tehachapis, and Los Angeles	51
5.	The SP Narrow Gauge, the SDA&E, and Pacific Electric	65
6.	The Southern Pacific at War	81
7.	"Men at Work" on the Southern Pacific	93
8.	"All Aboard!": From Union Stations to Whistlestops	109
9.	Wrecks, Rescues, and the Scrapper's Torch	119
Bibliography		127

ACKNOWLEDGMENTS

When a writer is asked to produce a photographic history of something as well-documented as the Southern Pacific in California, even when you narrow it to roughly the years between 1920 and 1960, the question that comes to mind is, "Where am I going to get fresh, unpublished pictures?" Fortunately, the first person I asked was my good friend and fellow Southern Pacific Historical and Technical Society (SPH&TS) member, Paul Koehler. Paul said, "I'll loan you my collection." That extensive and well-organized body of photographs is the heart and soul of this book. Paul gleaned the images from his years as an officer with the Southern Pacific Railroad and as an avid admirer of the SP. Everyone who reads this book is in debt to his enlightened acquisitiveness, and his generosity, but no one is more in debt than I. I am also grateful for the generosity of SPH&TS members. As editor of the society's newsletter, I asked members to give me access to their photograph archives. Leeanne Curts was among the first to reply, opening up the collections of her husband, Dick, and his now-deceased friends, Donald R. Latham and Marvin R. Galloway, both longtime SP railroaders who documented their time on the job with the little personal cameras of the day. Allen Aldritch, Gary B. Jones, and others provided photographs they had shot themselves as they pursued the romance of railroading in the 20th century. Joe Dale Morris, the author of *Southern Pacific's Slim Princess in the Sunset*, the story of Southern Pacific's narrow gauge railroad in the shadow of the Sierra Nevada, provided me with absolutely essential guidance as I prepared to write my first book. Former SPH&TS president Paul Chandler was also more than helpful, as was Signature Books publisher and SPH&TS director Tony Thompson. Special thanks go to my editor, John Poultney, who recruited me for the project and then expertly shepherded me through the long process of organizing, writing, and proofreading this book.

INTRODUCTION

The Southern Pacific Railroad of the 20th century is the natural child of the 19th century's Central Pacific Railroad. Together, the Central Pacific and the Union Pacific formed the transcontinental railroad, the engineering triumph of the 19th century. It was a work astoundingly completed almost entirely by hand. Think of it: mountains conquered, tunnels blasted, rivers bridged, 2,000 miles of roadway graded, millions of ties cut and placed, rails hammered into alignment—all without a single machine. In the case of the Central Pacific, every rail, every spike, every piece of steel, had to come from the forges and foundries of New England, or England itself, and be manhandled across Panama or sailed around the tempests of Cape Horn.

The building of the transcontinental railroad took the engineering, management skills, and teamwork that had been learned and honed in the Civil War and turned those talents to a transforming work of peace. The end of it was something new on the face of the world, something revolutionary. A continent had been tied together with bands of steel. Over that route new immigrants and restless Americans moved easily into a raw land, exploiting its bounty. The railroad united them, hauled the products of their labor to markets new and old, and gave them a freedom of movement unimaginable in the days of foot and horse. And with the railroad came the wire, the telegraph—a means of instant communication with profound social and political effects.

As historian Stephen Ambrose writes in *Nothing Like It in The World*:

> Together, the transcontinental railroad and the telegraph made modern America possible. Things that could not be imagined before the Civil War now became common. A nationwide stock market, for example, a continent-wide economy in which people, agricultural products, coal, and minerals moved wherever people wanted to send them, and did so quickly and cheaply. A continent-wide culture in which mail and popular magazines and books that used to cost dollars per ounce and had taken forever to get from the East to the West Coast, now cost pennies and got there in a few days.

It would be no great exaggeration to say that first the Central Pacific and then the Southern Pacific Railroad shaped the growth and development of California into an economic and political powerhouse that could, and did, take its place on the world stage. The railroad built on its transcontinental foundation to expand rapidly into Northern California and Oregon, with their endless tracts of forest felled to provide the wood and timber for growing towns and cities. Other lines snaked into the San Joaquin Valley, a breadbasket so fertile it would feed a nation. Growth was the hallmark of the SP.

By the end of the first two decades of the 20th century, the Southern Pacific was a magnificent work of machines. Its steam locomotives and their trains of passengers and freight roamed from the Columbia River to the Mississippi, from San Francisco Bay to the Gulf of Mexico. Yet the SP's heart and headquarters were in California. Milepost 0.0 was the hinge of the front door on the Ferry Building in San Francisco. The railroad's own steam ferries carried passengers dressed in their Sunday best to the great train sheds on the Oakland Mole, where they boarded Pullman cars, parlors, and coaches to carry them north to Portland, south to Los Angeles, east to Omaha and Chicago, with connections to hundreds of distant cities and towns. A few blocks away from the Ferry Building, passengers at SP's Third and Townsend station boarded commuter trains that took them down the peninsula to San Jose and to Monterey and Carmel. Still other passengers sailed out of the city on elegant express trains down the famous Coast Line to Los Angeles and on to New Orleans. Within a few years, those same rails would carry the magnificent streamliners of the passenger train's golden age, trains bearing the names of the *Overland Express*, the *49'er*, the *Coast Daylight* and its companion *San Joaquin Daylight*, the *Lark*, and the *Sunset Limited*. Together with the Union Pacific and the Chicago and North Western Railroads, the SP would operate the *City of San Francisco*, not incidentally ushering in the diesel locomotives that would doom the mighty steam engines.

If almost everything else about the railroad had changed in its transition from the Central Pacific of 1869 to the Southern Pacific of the 1920s and beyond, the central mission remained the same. The railroad transported products from producer to consumer, produce from field to market, and people from place to place. It was still California's essential mainline of communication, still a network that bound a vibrant populace together. From the 1920s through the 1950s the SP—indeed all American railroads—would thrive in their greatest accomplishments, especially during World War II.

For all the power and drama of its magnificent machines, the Southern Pacific of the early and middle 20th century was, as it had been in the beginning, a work of men. From Sacramento to Promontory, the Central Pacific was hacked, shoveled, drilled, blasted, and sledgehammered into place, largely by Chinese men. Highly regarded as railroad builders, many of those men and their kin went on to build the Great Northern and Northern Pacific railroads, but, call it racism if you will, they did not stay on in permanent jobs with the Central Pacific. Instead, the jobs of engineers, firemen, brakemen, and such went to the more unruly Irish and Central European workers who had rushed the Union Pacific west from Omaha.

They took the jobs, and they stayed. Railroading is something that gets in the blood, sometimes for generations. My own grandfather worked on the Pennsylvania Railroad for 52 years and gave both his grandsons a love of trains that endures to this day. However, the railroader's love of railroading was not the same as love of "The Railroad." The Southern Pacific, after all, was no better in its relationships between management and rank-and-file than any other big corporation, then or now. Strikes were not uncommon, and Big Four member Henry Huntington's disdain for his workers was legendary.

Still, whether management or labor, a job on the Southern Pacific brought railroaders pride, a sense of accomplishment every working day along with a lasting fascination with the great machines in their care. You will see that pride, that fascination in the photographs that make up this book. They are pictures that put the Southern Pacific into the essential fabric of California, the warp and woof. Many of the pictures were commissioned by the railroad itself, the product of professional photographers; others are the work of enthusiastic amateurs, often quite accomplished. Still others, taken by railroaders going about their daily jobs, get to the soul of railroading. What they lack in professional skill, they make up for with heart. Here it is, then, *Southern Pacific in California*.

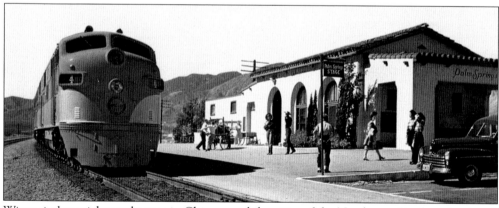

Winter is downright unpleasant in Chicago and the cities of the Northeast. On the other hand, winter is really quite enjoyable in Palm Springs, California. This 1946 photograph shows the *Golden State*, a Chicago-to-Los Angeles train jointly operated by the Southern Pacific and Rock Island railroads, arriving at the recently modernized Palm Springs depot. The train itself has been modernized in the postwar era. Three General Motors Electro Motive Division 2,000-horsepower E7-model diesel-electric locomotives pull a string of new, lightweight Pullman sleeping cars and coaches painted in a striking scarlet and silver scheme. Palm Springs and its surrounding desert resort communities had been a popular destination for snowbirds since the beginning of the 20th century. The postwar population expansion of the West would turn the resort area into a boomtown. (Southern Pacific photograph, Paul C. Koehler Collection.)

One

THE SOUTHERN PACIFIC: A MOUNTAIN RAILROAD

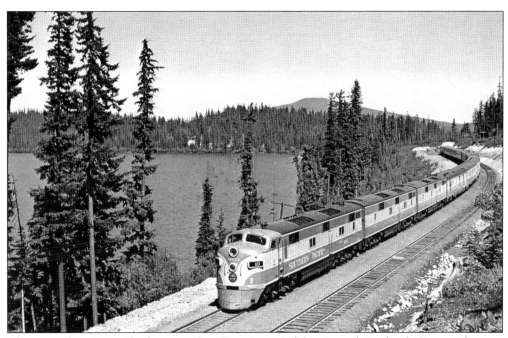

The more than 700 miles between San Francisco, California, and Portland, Oregon, features some of the handsomest mountain scenery in the world. In the early summer of 1949, Southern Pacific introduced a new train, the *Shasta Daylight*, to take advantage of the spectacular views along the Sacramento River and through the Cascades. The brand-new, lightweight streamlined passenger cars featured extra-tall windows. Later, Southern Pacific's Sacramento Shops would rebuild lounge cars into dome-lounge cars to make the scenic experience even more enjoyable. The fully air-conditioned, all-coach consist offered travelers the comforts of foam-padded adjustable seats as well as the amenities of diner, coffee shop, lounge, and tavern cars. (Southern Pacific photograph, Paul C. Koehler Collection.)

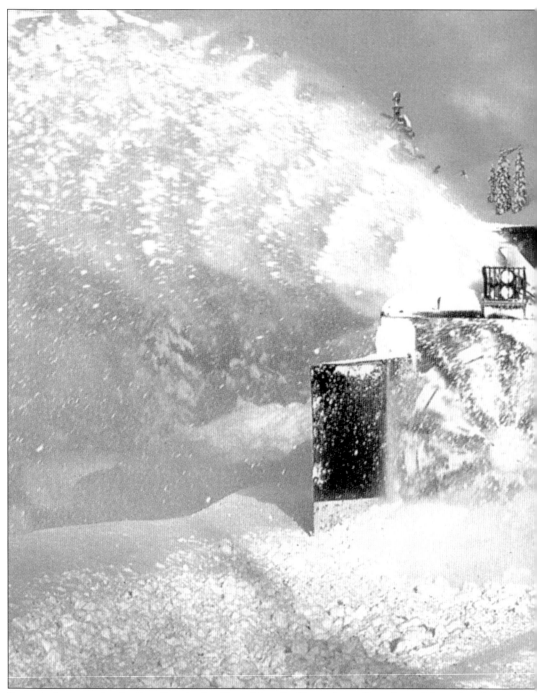

Snow is the nemesis of railroading in the Sierra Nevada. From the earliest days of the railroad on through the present day, Southern Pacific (and now Union Pacific) have faced a major battle to keep the line open. It is a contest fought with the most powerful weapons the railroad can bring to bear, along with a small army of men. This special snow-fighting train leads the charge. To avoid turning problems, it has a rotary plow on either end, powered by diesel-electric generator sets housed in F-7 B-unit carbodies. Formerly road power, the B-units have had their traction motors removed

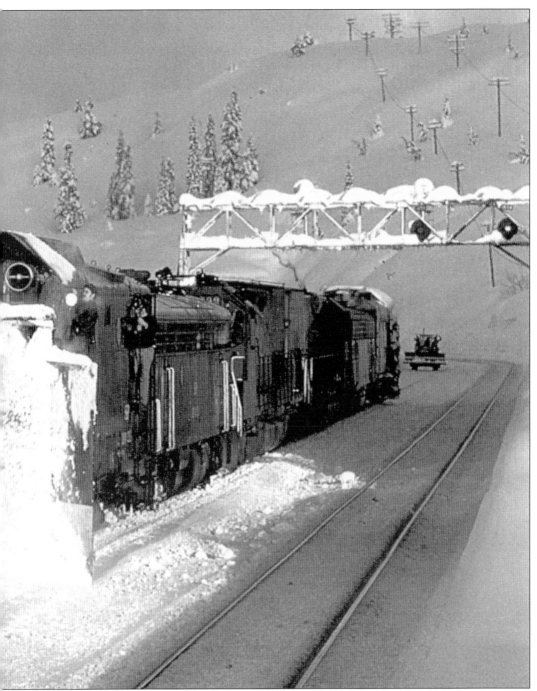

and are no longer capable of moving themselves. Instead, all the energy from the main generator drives the 11-foot, six-inch blade of the rotary. Motive power comes from a pair of the road's newest, most powerful locomotives. In 1981, when this photograph was taken, that was Southern Pacific's distinctive SD-45-T2 3,600-horsepower Tunnel Motors, designed specifically for service in the snowsheds and tunnels of the Overland Route. (Southern Pacific photograph, author collection.)

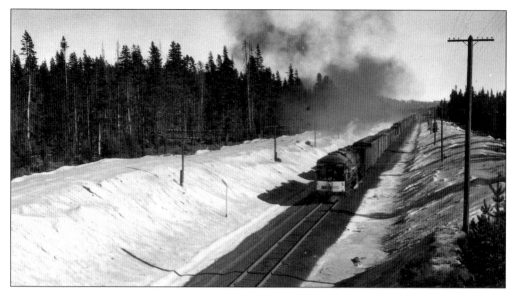

Snow is a factor in railroading anywhere in the western mountains. Here, Southern Pacific's main line through the Cascades has been cleared. The snow has melted off the ballast, and the snowbanks along the line have retreated, perhaps an indication it is late in the season. One of the railroad's lumbering Articulated Consolidation (AC) locomotives is headed north out of Dunsmuir returning empty boxcars to Eugene, Oregon. (Paul C. Koehler Collection.)

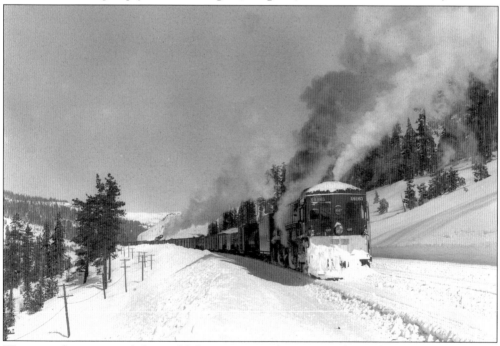

Winter is often stunningly beautiful, but it is serious business in the High Sierra, where annual snowfall can exceed 60 feet. Southern Pacific cab-forward 4167 heads a westbound freight just after a fresh snowstorm—neither the first nor the last of an always severe High Sierra winter. To keep the line clear, the railroad maintained a fleet of snowplows, flangers, spreaders, and a staff of workers armed with shovels. (Paul C. Koehler Collection.)

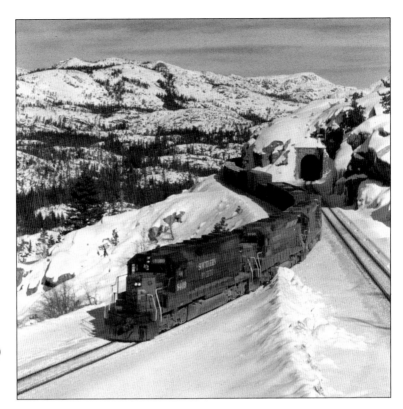

The name Donner Pass recalls a winter tragedy in the High Sierra when the Donner Party of pioneers was trapped in heavy snow while moving west before the railroad was built. Extra 8409 west curves around the outside of a tunnel reserved for eastbound traffic near Donner Summit. The heavy manifest freight is west of Truckee and east of Norden, bound for Roseville. (Paul C. Koehler Collection.)

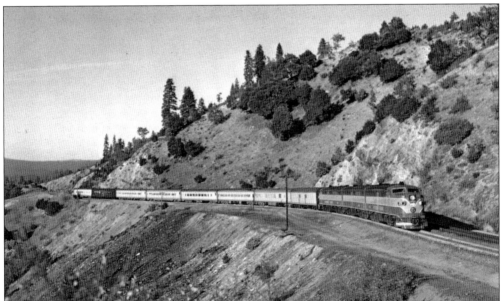

Headed by Southern Pacific Alco PA diesel units in the mid-1950s, the eastbound *San Francisco Overland* is not far from the towering Cape Horn section of the transcontinental railroad in the Sierra Nevada Mountains near Colfax, California. Before World War II, the *Overland Limited* was an all first-class luxury train running between Chicago and San Francisco. After the war, when the train was streamlined, coaches were added to the consist. (Paul C. Koehler Collection.)

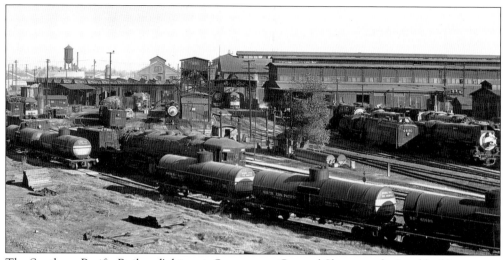

The Southern Pacific Railroad's historic Sacramento General Shops are depicted looking east in the mid-1950s from a highway bridge where Interstate 5 crosses now. The General Shops were the maintenance and logistics base for the Central Pacific Railroad as it built east to meet the Union Pacific. The shops were home base for SP railroad operating equipment, the place where locomotives and passenger and freight cars went for general overhaul. (Paul C. Koehler Collection.)

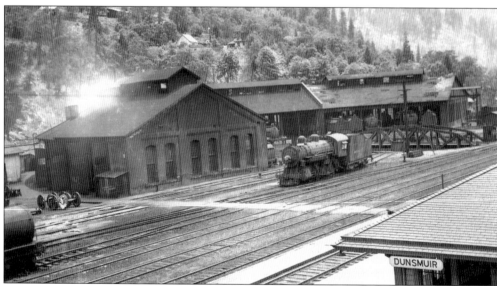

The roundhouse in Dunsmuir, California, is next to the Sacramento River, so close in fact that the engine house and yard were sometimes flooded during heavy rainstorms or with runoff from melting snow. The 2-8-0 Consolidation locomotive has an unusual rectangular tender. The SP acquired these engines when it took over the coal-fueled El Paso and Southwestern Railroad from the Phelps Dodge Corporation. (Paul C. Koehler Collection.)

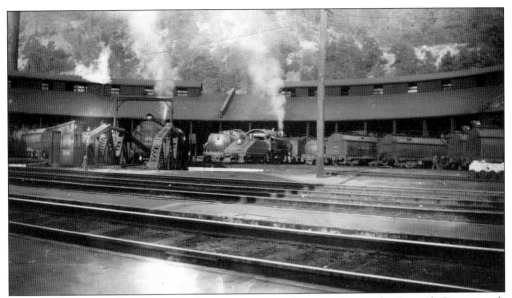

The Dunsmuir roundhouse was the first major engine change point on the Cascade Route north from Sacramento to Oregon. It was always busy servicing and storing the cab-forward freight locomotives as well as passenger power, local freight, and switch engines. A small yard at the south end of the station area served to make up and break up freight cars for Dunsmuir-area businesses. (Paul C. Koehler Collection.)

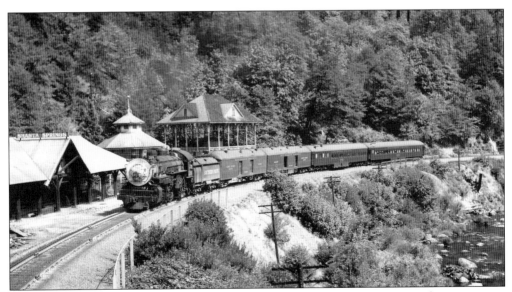

Train 328, the *Scoot*—a handsome affair with its Pacific 4-6-2 steam engine, two baggage cars, a coach, and a Pullman—pauses at Shasta Springs to unload passengers for the resort near Mount Shasta. The train originated in Oregon and terminated at Dunsmuir, where rural passengers could connect with mainline trains bound for Sacramento and points west and south. (Paul C. Koehler Collection.)

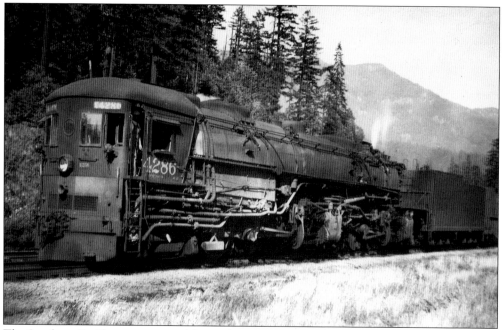

The Southern Pacific was renowned for its gleaming GS-class red, orange, and black streamlined passenger engines, but brutes like AC-12 Articulated Consolidation 4286 were what kept the accountants happy. The big 4-8-8-2s could drag heavy freight tonnage or extra-length passenger trains up mountains and down valleys in any weather. (Paul C. Koehler Collection.)

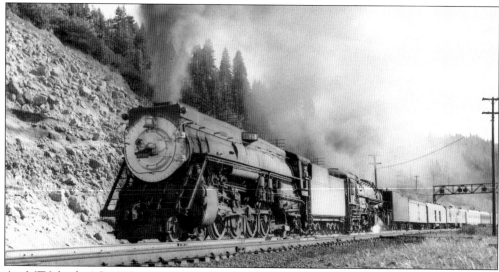

An MT-2 leads AC 4385 on Train 23, the *Overland*, eastbound on the Overland Route, high in the Sierra Nevada. A scene almost identical to this was repeated every day, westbound and eastbound, in the wartime 1940s and into the 1950s. The first car after the articulated's tender is an express refrigerator, used for high-priority perishable cargo, such as strawberries. (Paul C. Koehler Collection.)

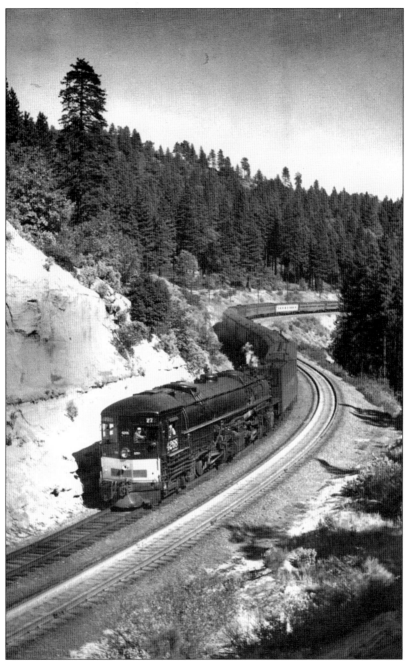

AC 4268 is at Blue Canyon, well up on the Hill, as the Sacramento to Reno route was known, with the westbound *Overland*. SP frequently used its big articulated engines to boost heavy passenger trains over the steep grades of the Sierra Nevada. The pace was not what one would consider express-train fast, but for crossing mountains several thousand feet high, the big engines provided steady pulling power. The *Overland* was often burdened with extra head-end mail and express traffic. The Union Pacific and the Norfolk and Western also used articulateds on passenger trains, but the Southern Pacific was the only railroad rostering cab-forwards. (Paul C. Koehler Collection.)

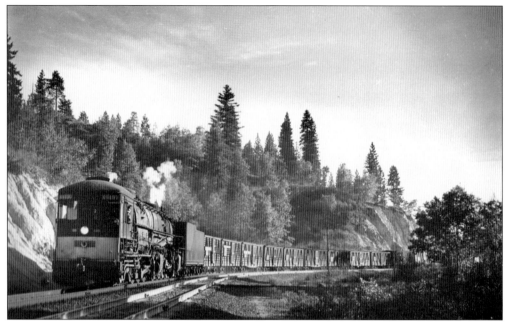

Extra west 4197 is running behind an AC-8 at Blue Canyon. Twelve stock cars are on the head end, where loaded cattle cars rode easier due to reduced slack action. Government rules for carrying livestock required cattle to be periodically released from the cars, rested, and watered. That setout was easier for the crew when the cars were at the front of the train. (Paul C. Koehler Collection.)

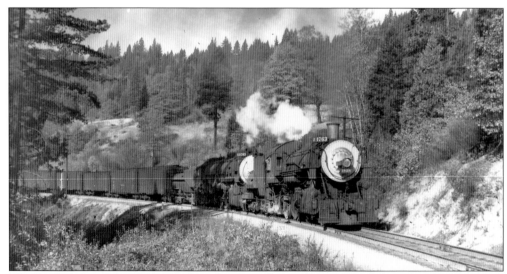

The Southern Pacific lines through the Siskiyous and Cascades were also helper districts, both uphill and down. Loaded downhill trains required extra assistance with braking. SP Mogul 1828 is the point helper on Extra West 3763. The 2-10-2 main engine and its train are probably southbound from Portland winding down to Dunsmuir, and on to Sacramento. (Paul C. Koehler Collection.)

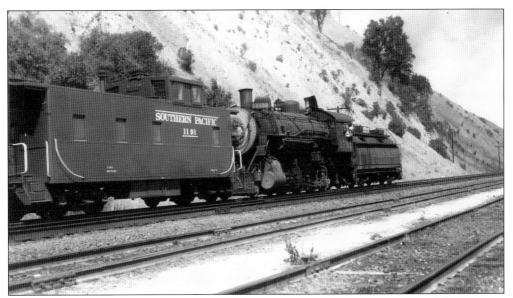

Trains in mountain districts often required additional helpers. Here SP Consolidation 2792 is shoving hard on the rear of caboose 1192 near Donner Pass on the Overland Route. Very long and heavy freight trains could have as many as six engines—two ACs on the front, two more cut in two-thirds of the way back, and two more shoving behind the caboose. (Paul C. Koehler Collection.)

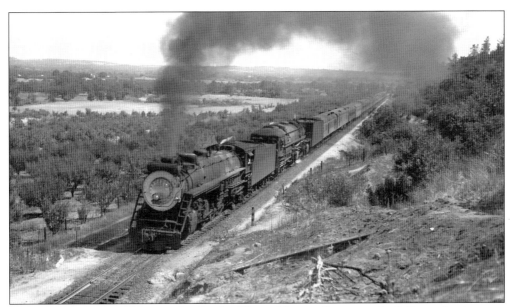

In the years before World War II, the *Overland Limited* featured heavyweight Pullman sleeping cars. In this photograph, a former El Paso and Southwestern MT-2 assists an Articulated Consolidation through the Sierra foothills with the eastbound *Overland*. The ferry from San Francisco is a good distance behind it, but Chicago is days away. (Paul C. Koehler Collection.)

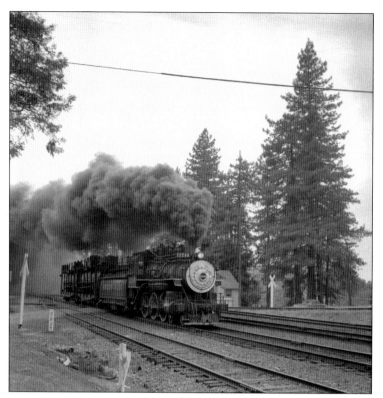

With all that smoke, engine 2488 seems to be in quite a hurry. It was specially equipped with pumps and fire hoses. Engine 2488 and its train of water tank cars was the Norden fire train. With steam engines occasionally spewing sparks, fire was a real danger along the Overland Route in dry summers, and almost any place where the snow sheds were built of wood. (Don Ball photograph.)

Fire train duty was a full-time assignment for Engine 2488. Despite its precautions, the Southern Pacific had suffered several disastrous fires in the miles of snowsheds, and the slopes of the High Sierra were often tinder-dry in summer and fall. The fire trains were kept on high alert, always ready to respond at the first report of smoke. (Don Ball photograph.)

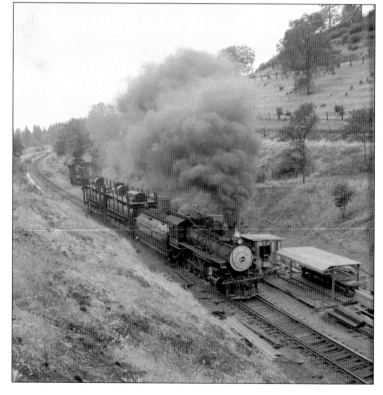

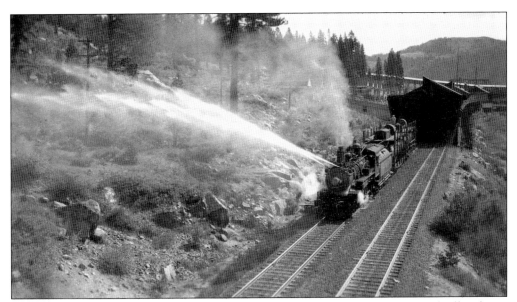

In this photograph we see both the High Sierra fire problem and its solution. With all its hoses spraying a timbered slope, the Norden fire train is coming out of one of many wooden snow sheds along SP's route over the Sierra. The fire train is on a practice run to keep the crew proficient. The wood sheds were later replaced with concrete sheds. (Paul C. Koehler Collection.)

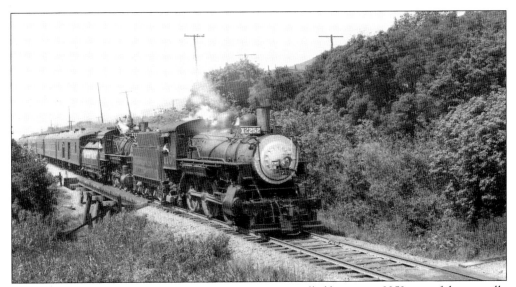

Mogul 1707 is the head-end helper to an excursion train pulled by engine 2252, one of the specially equipped fire train engines. Toward the end of steam, these small engines were put together in short trains of Harriman-style 60-foot passenger cars. These light trains could meander down a branch line that would never again see passenger service behind steam. (Paul C. Koehler Collection.)

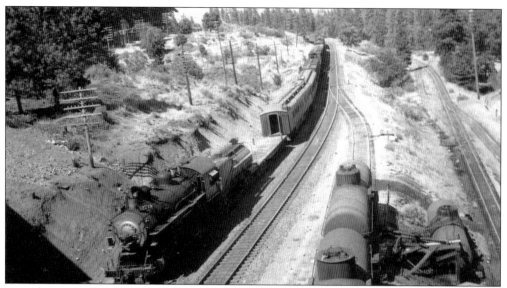

A work train pulled by Consolidation 2716 is westbound at Colfax. Work, or maintenance of way trains, were an assortment of outdated freight and passenger equipment, with the passenger cars serving as living and office space, while the freight cars were modified to fill a wide variety of construction and maintenance jobs. (Paul C. Koehler Collection.)

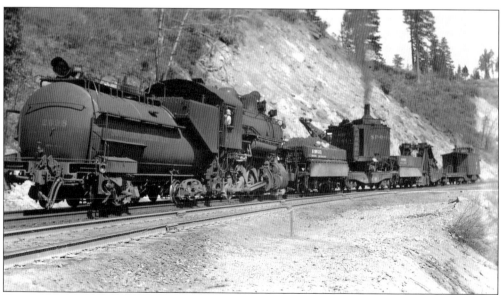

Keeping Southern Pacific's Overland Route operating over the Sierra was a full-time job for the railroad's maintenance of way (MOW) crews. 2-8-0 Consolidation 2658 is running tender-first at the head of a work extra. Crewmen are using a steam-powered dragline to clean up dirt and rock that slid down the slope, clogging the drainage ditch next to the track. (Paul C. Koehler Collection.)

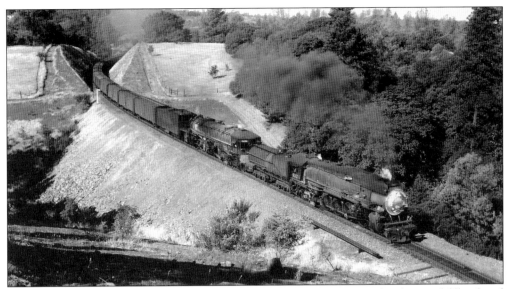

A Mountain-class leads an Articulated Consolidation in a perfect example of cut-and-fill railroad right-of-way construction. The eastbound perishable is heading uphill on the west slope of the Sierra after leaving Roseville. All the reefer ice hatches are closed, indicating fully-iced "protected" service, which will require regular stops for re-icing. (Paul C. Koehler Collection.)

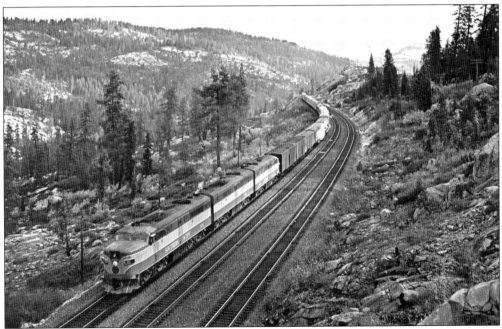

Southern Pacific's *San Francisco Overland* is less than 200 miles from its namesake city in the care of three red and orange Alco passenger units on the west slope of the High Sierra. The Alcos proved highly adept at powering trains in the mountains. Their pairs of three-axle trucks carried a traction motor on each axle, giving them more tractive effort than EMD E-units. (Southern Pacific photograph, Paul C. Koehler Collection.)

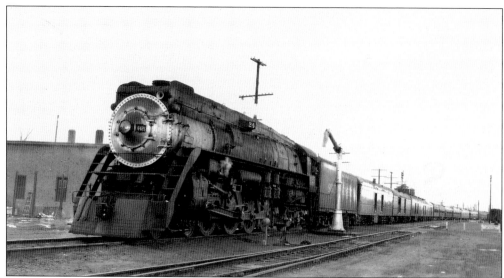

Train 24, The *Gold Coast* (also called "the Cold Roast" by railroad writer Lucius Beebe) operated between San Francisco and Chicago. It went into postwar service in October 1947, replacing the *San Francisco Challenger*. The train offered travelers lower fares than the luxury trains on the Overland Route, and usually carried several head-end cars. (Paul C. Koehler Collection.)

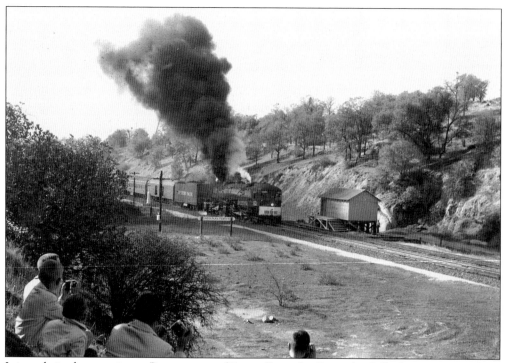

It is early in the morning at Penryn, east of Roseville in the Sierra foothills, but not too early to keep the railfans from clustering to photograph what is probably one of the final runs behind a cab forward. After a few runs by for the cameras, most of the fans will reboard the *Excursion Special* for the run to the Oakland pier. (Paul C. Koehler Collection.)

Two

TRAINS TO SAN FRANCISCO BAY

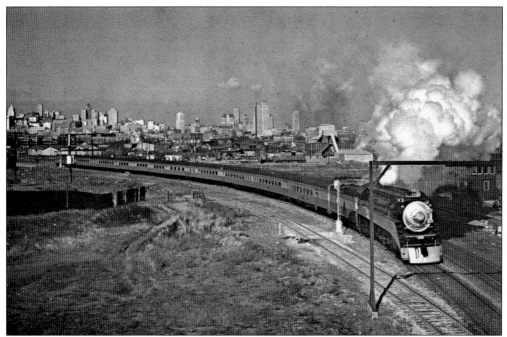

The year is 1947 and the skyline of San Francisco looms behind Southern Pacific train No. 96, the *Noon Daylight*, as it bends into the curve turning it south for its dash down the bay shore towards San Jose and its ultimate destination, Los Angeles, some 470 miles away on the Coast Line. During the war, many of the GS-class engines were painted a drab black, but those in regular Daylight service retained the gleaming red, orange, and black Daylight livery. In all, five trains will carry the Daylight name. The *Morning Daylight* also links San Francisco and L.A., while the *San Joaquin Daylight* serves passengers between Oakland and Los Angeles. The *Sacramento Daylight* exchanges cars with the *San Joaquin*, while the *Shasta Daylight* between Oakland and Portland, Oregon, will not start until 1949. (Southern Pacific photograph, Paul C. Koehler Collection.)

It does not look like it, but this scene is practically in downtown San Francisco. Train No. 72, the *Los Angeles Passenger*, is just a few minutes out of San Francisco's Third and Townsend Streets depot. GS-4 4457 is nicely framed by Tunnel Five. No. 72 is laden with mail and express the luxury *Morning* and *Noon Daylights* do not carry and makes many more stops. (Southern Pacific photograph, Paul C. Koehler Collection.)

It is during World War II, and the eastbound *Sunset Limited* is running in two sections. First No. 2 has a head-end helper as it nears San Luis Obispo, an indication the train is well over its standard length and weight. The train is all heavyweight cars, with streamlined lightweight stainless steel cars not due to arrive until 1951. (Paul C. Koehler Collection.)

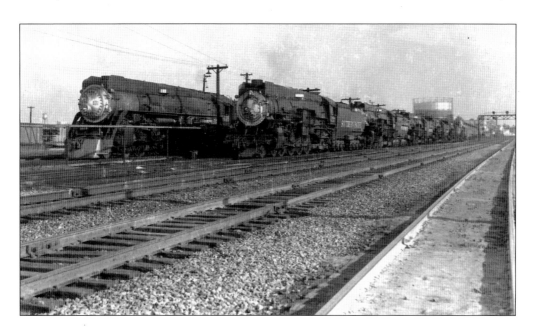

The Southern Pacific was heavily involved in commuter traffic in the bay area, with morning and evening rushes up and down the peninsula between San Francisco and Palo Alto. In the photograph above it is late afternoon, and the GS- and Mountain-class engines are staged just around the corner from the Third and Townsend depot, waiting to pull the evening commuters home. Below, one of the lighter engines in the commute pool is taking on water. When they were called, the north-facing engines would pull into the wye just west of the station, then back down to their trains. South-facing engines simply backed around the curve. (Both photographs, Paul C. Koehler Collection.)

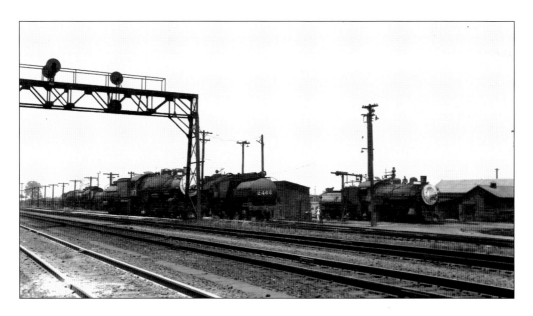

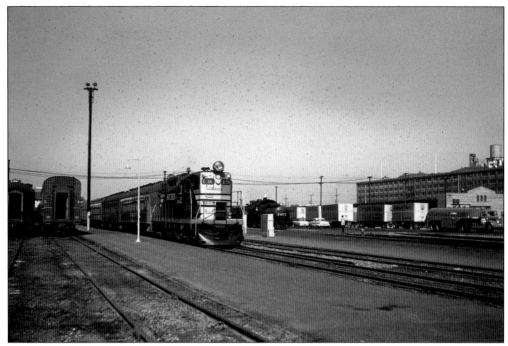

In the 1955 photograph above, double-ended passenger GP-9 5602 is at the Third and Townsend Streets station with train No. 78, the first section of the *Del Monte* to the Monterey Peninsula. Below, the locomotive in the background above is Pacific 2477. The locomotive's tender is equipped with a pilot. It and similarly equipped 2476 were in service on the Los Gatos Branch, where there were no engine-turning facilities. At the end of the run from San Francisco, the engines ran around their train, coupled on the rear and ran backwards to the city. (Alden A. Armstrong photographs.)

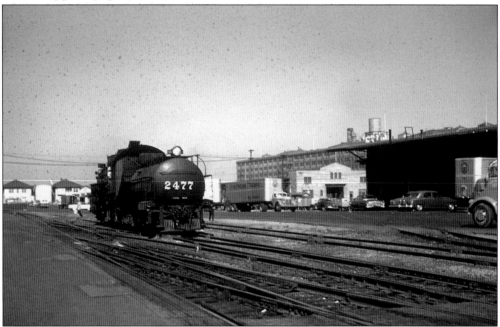

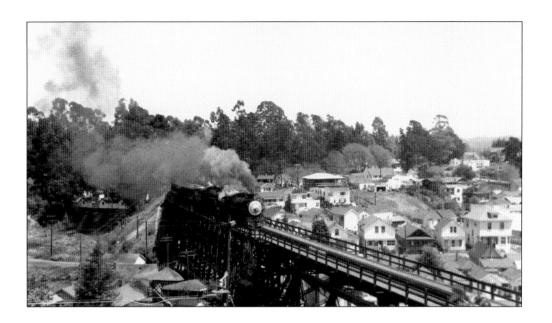

Double-headed 10-wheelers on the Santa Cruz branch power an excursion train on the trestle leading into the seaside town. These beach trains were extremely popular in the 1930s, 1940s, and 1950s, hauling passengers from San Francisco down the peninsula and across the mountains for a day at the beach and the amusement park, with its huge wooden roller coaster. Originally a San Jose to Santa Cruz operation, the *Sun-Tan Specials* quickly added San Francisco and Oakland as terminals. In the 1930s, a round-trip ticket went for $2.25. The trains were so popular that SP reported it sold 17,000 tickets for the 1939 season. One drawback was the trip took three hours and 15 minutes from San Francisco to the boardwalk. (Both Photographs, Paul C. Koehler Collection.)

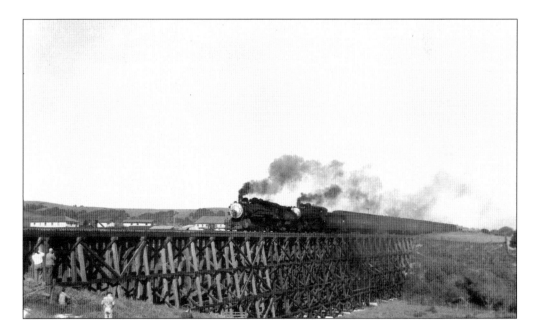

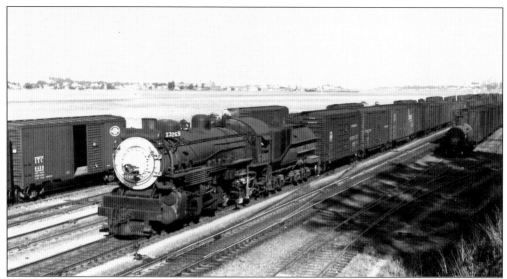

A local freight operating near Port Costa features an unusual engine for its power. Mikado (2-8-2) 3269 is one of only two Southern Pacific Mikados with Elesco feedwater heaters, the large tube at the top of the smokebox. Feedwater heaters used exhaust steam to heat water from the tender, thus maintaining higher steam temperature in the boiler, but they cost more to install and maintain. (Paul C. Koehler Collection.)

The West Oakland yard was a busy place in the early 1950s, where steam engines still bustled freight cars about, and the first diesel switchers were on the property. In the photograph, the best parking spot on the lot goes to the 1951 Studebaker, by the crossbuck at left. The yard received and dispatched freight trains for movements north and south as well as serving the busy East Bay industrial area. (Paul C. Koehler Collection.)

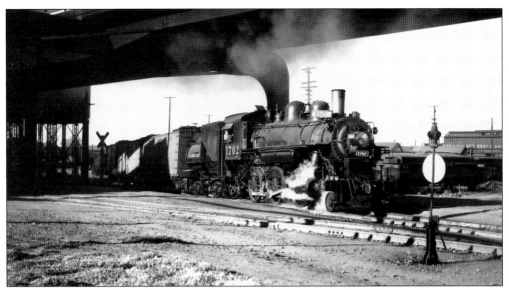

Mogul 1702 drags a string of refrigerator cars under an Oakland highway bridge and past a water tank. SP had more than 300 of these useful little locomotives working on all parts of the system, from Portland to Mazatlan and east as far as New Orleans. They were powerful for their size, and easy on the light track of branch and secondary lines. (Paul C. Koehler Collection.)

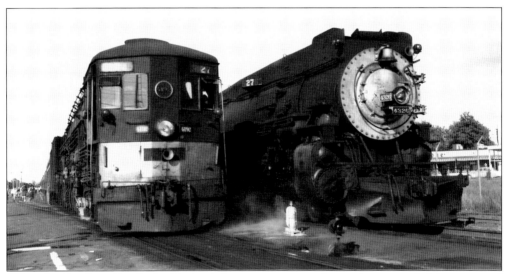

When the Southern Pacific double-headed passenger power, the combination of a Mountain and a cab forward was a favorite. Mountain 4326 has just uncoupled from the head end of No. 27, the westbound *Overland* at Roseville. Engine 4192, an AC-8, has more than enough power to take the train into Oakland. (Paul C. Koehler Collection.)

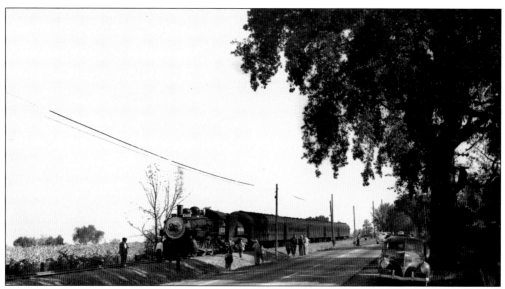

One of Southern Pacific's many Moguls is sufficient power to pull a five-car excursion train of Harriman-style 60-foot passenger cars. The train appears to be an outing to the Napa Valley. Those are grapevines in the background, and there may have been a fruit stand out of sight to the right. It does suggest a wine train through the Napa Valley! (Paul C. Koehler Collection.)

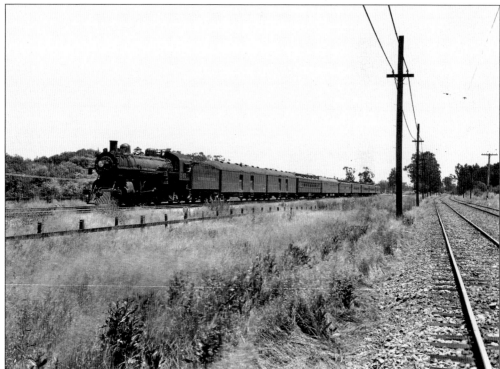

This very early 20th century edition of the *Sunset Limited* has just nine cars behind a light Pacific. It is running railroad west, compass north on the peninsula near San Jose. It left New Orleans days ago, and is nearing its San Francisco destination. The gleaming, air-conditioned, stainless steel and red *Sunset Limited* of the 1950s is years in the future. (Paul C. Koehler Collection.)

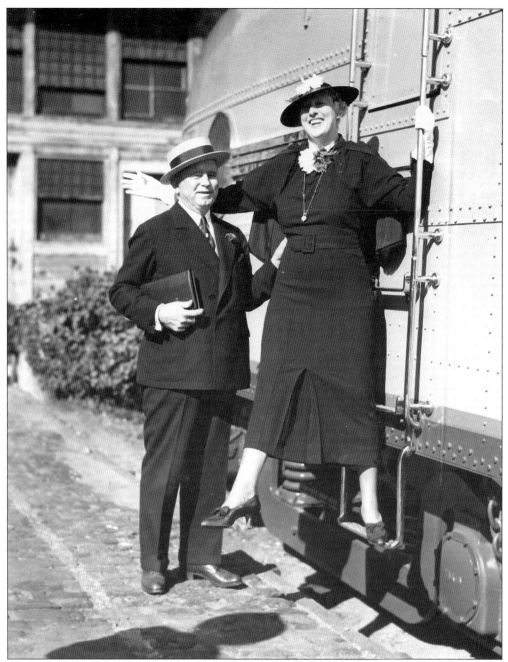

When Southern Pacific wanted to publicize its new diesel locomotive for the streamlined *City of San Francisco*, it followed the public relations axiom "First, get an actress." These days, that might mean a size 00 celebrity with more notoriety than talent, but in 1936 SP's choice was Charlotte Greenwood, a critically acclaimed star of vaudeville, Broadway, radio, and movies. She was around 6 feet tall and claimed she could kick a giraffe in the eye. The somewhat shorter gentleman in the straw boater is J. H. Dyer, Southern Pacific's general manager of the Pacific Division, a man intimately involved with bringing the *City of San Francisco* to life, in a joint venture with the Union Pacific and Chicago and North Western railroads. (Paul C. Koehler Collection.)

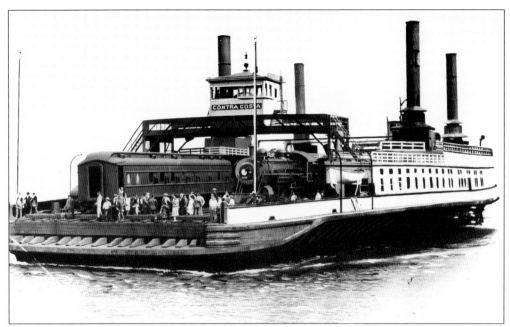

Yes, the Southern Pacific had a navy! The SP ferry *Contra Costa* transported entire trains and their passengers between Benecia and Port Costa prior to the building of the great rail bridge over the Carquinez Straits in the late 1930s. SP's San Francisco Bay ferries, which ran between the city's Ferry Building and the Oakland Pier, were strictly for people. (Paul C. Koehler Collection.)

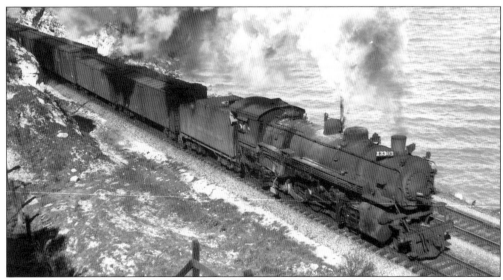

In the heyday of steam, the area northeast of Oakland was heavily industrialized and very dependent upon the railroad for the movement of raw materials and finished goods. Relatively short trains working out of West Oakland Yard took care of business. Mikado 3303 has the duty this day, working local freight east along Carquinez Strait. (Paul C. Koehler Collection.)

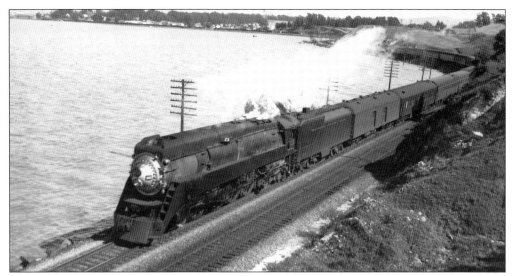

In about 1946, Train 23 is galloping along the Carquinez Strait on the final leg of its run from Portland to Oakland. GS-4 4433 wears the all-black paint typical of engines assigned to the Shasta and Portland divisions. The numerous tunnels along the route made it impossible to keep Daylight paint clean—so SP didn't. (Paul C. Koehler Collection.)

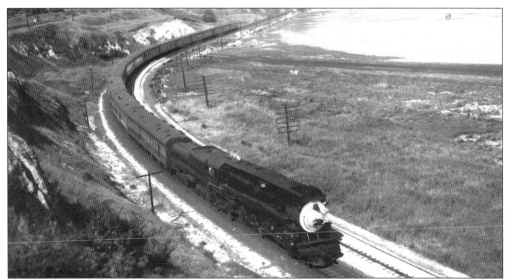

The *San Joaquin Daylight* runs eastbound between Port Costa and Martinez along the Carquinez strait. Mountain type MT-4 4351 will later be painted in a modified Daylight scheme for exclusive use on this train. The distinctive first two cars are older Harriman heavyweights modified and semi-streamlined for baggage and mail service on this train. (Paul C. Koehler Collection.)

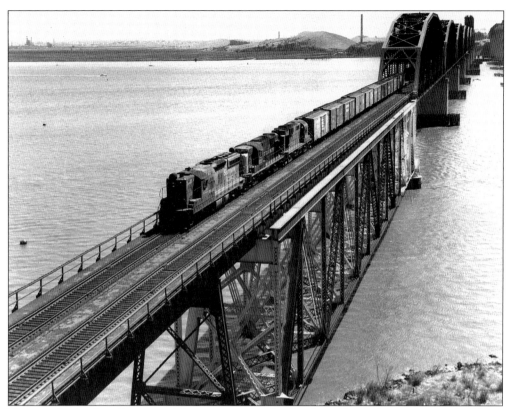

The great bridge from Benecia to Martinez put an end to Southern Pacific ferry service in the Upper Bay but vastly increased the amount and frequency of freight movement. The manifest freight on the bridge is heading west to Oakland behind an SD-9 with Gothic lettering and a pair of Alco RS-11s. The piers of Interstate 80 are just visible at right rear. (Paul C. Koehler Collection.)

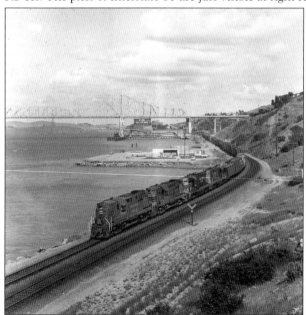

Two Alco RS 11s are on the point with two EMD Geeps behind on this westbound manifest freight rolling toward Oakland. The Crockett–Napa Bridge is in the far background, with the California and Hawaiian (C&H) sugar plant at Crockett in the middle distance. The plant processed sugar cane from Hawaii, brought in by ship. (Paul C. Koehler Collection.)

Three

THE GREEN AND GOLD COAST LINE

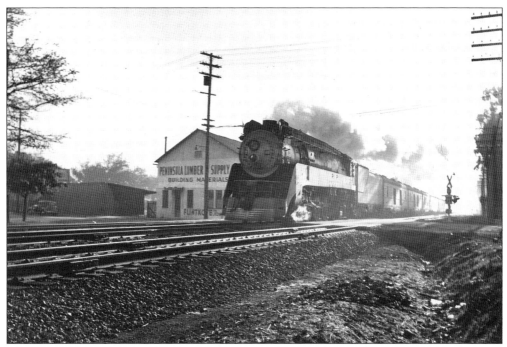

The first section of the Lark races up the peninsula toward its early morning arrival in San Francisco. For the rail aficionado, the position of the number boards at the front of the skyline casing is a giveaway that this photograph was taken early in World War II, before they were moved back to the center of the casing, where they were shielded from the glare of the GS-4's Mars light. It is also still in Daylight livery instead of wartime black and has its chrome pilot strips intact. (Paul C. Koehler Collection.)

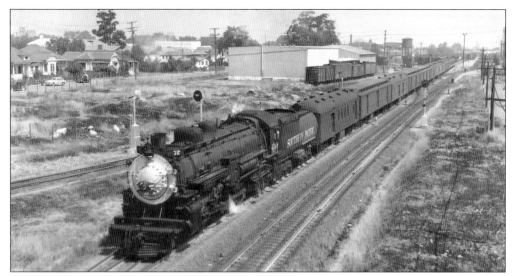

"Sad Sam," train 72, the *Coast Mail*, is running behind a Mountain-type 4-8-2, just leaving San Jose for its long, slow run to Los Angeles. The *Coast Mail* hauled mail and express between Oakland and Los Angeles and back again, making frequent stops to provide daily postal service to communities well before the job was taken over by trucks on new, government-built highways. (Paul C. Koehler Collection.)

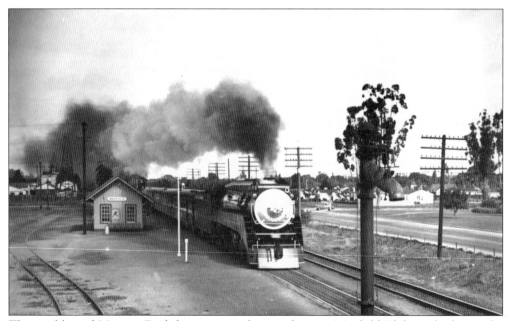

The southbound *Morning Daylight* races past the tiny depot at Mayfield. If things had gone the way Leland Stanford planned, Mayfield would have been much grander. In 1886, Stanford wanted to found his university there, on one condition: alcohol had to be banned. The patrons of the town's rowdy saloons disagreed, so Stanford University went to Palo Alto, where the students are sober to this day. (Paul C. Koehler Collection.)

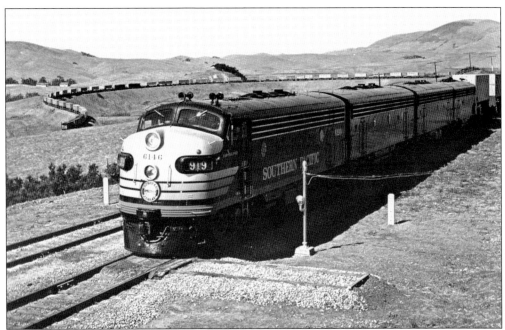

Horseshoe Curve below Chorro siding seems almost designed to show off trains climbing north up Santa Margarita Pass from San Luis Obispo, California. A company photographer has posed a squeaky-clean four-unit set of EMD F-7 diesel units on the point of Southern Pacific train No. 919, to demonstrate the railroad's then-new all piggyback freight. (Southern Pacific photograph, Paul C. Koehler Collection.)

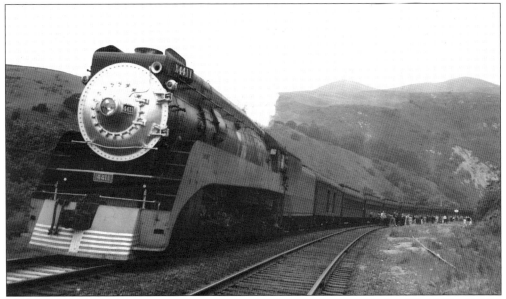

GS-2 4411 pauses while on an excursion run in the Cuesta Mountains before World War II. The brilliantly Daylight-painted GS engines were quite new then and extremely popular with railfans and the traveling public. The train will probably back up, and then, making as much smoke and steam as possible, dash by for a photograph opportunity, with all opposing and overtaking traffic delayed. (Paul C. Koehler Collection.)

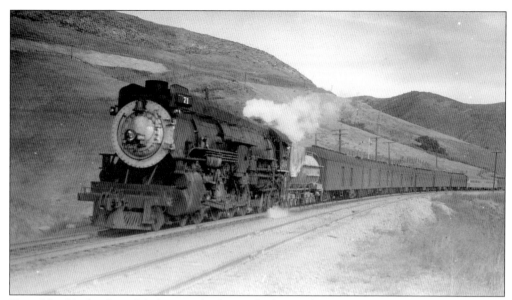

Train No. 71, the *Coast Mail*, is on the low end of Horseshoe Curve in the Cuesta Mountains behind a Mountain with an extremely alkali-stained tender. A pair of articulated Daylight coaches are rather grander accommodations than the *Mail* usually afforded, and are, in fact, empty, deadheading back to San Francisco. (Paul C. Koehler Collection.)

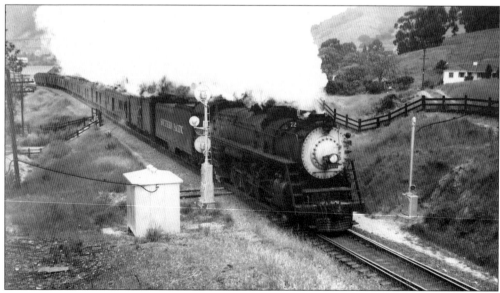

Relatively rare on the West Coast, GS-1 4402, a visitor from the Texas Lines, has the southbound *Coast Mail* well in hand behind a plume of white steam as it passes the signal just north of San Luis Obispo. The first car behind the tender is an express boxcar, followed by the working railway post office, and then a long string of baggage and express cars. (Paul C. Koehler Collection.)

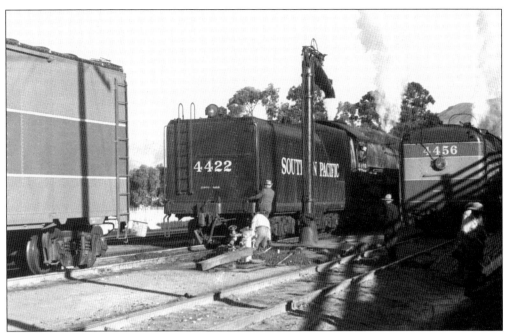

San Luis Obispo was a major point on the Coast Line, a place where locomotives were exchanged or helpers added or removed. In the photograph above, GS-3 4422 is coming off its mail train, with GS-4 4456 ready to take its place. The two-tone gray boxcar at left is something of a rarity. Although SP had dozens of express boxcars, only three were painted in the Lark scheme. Along with its passenger station and freight yard, San Luis had full engine service facilities, including a roundhouse and turntable. Below, engine 3688, a 2-10-2, tops off its oil tank. Sand is available from the tower just ahead of the locomotive. (Alden A. Armstrong photographs.)

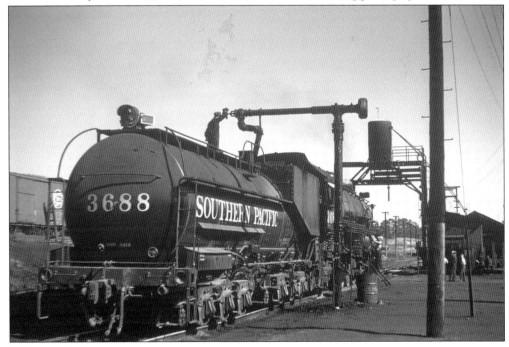

41

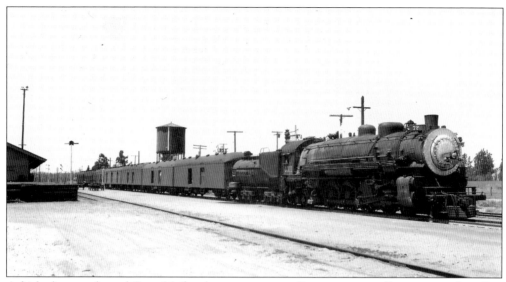

A fairly short eastbound *Coast Mail* makes a station stop. By convention, all trains away from San Francisco were labeled "eastbound," no matter their compass direction of travel. Similarly, all trains headed toward San Francisco were "westbound." This train has two rider coaches instead of the usual single car. No one wanted to ride the slow mail trains. (Paul C. Koehler Collection.)

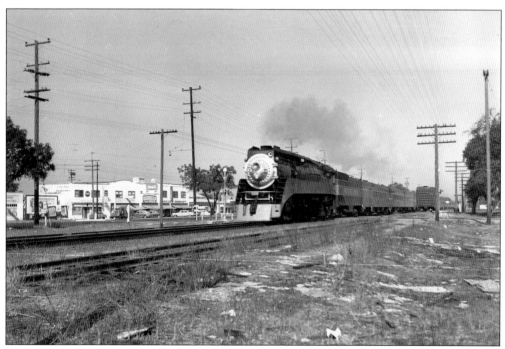

Although the landscape is hardly the stuff of picture postcards, the *Coast Daylight* is going about its business at track speed, still north of Watsonville Junction as it hustles its trainload of passengers south to Los Angeles. Judging from the cars parked outside the stores in the background, the date is sometime in the early 1950s. (Paul C. Koehler Collection.)

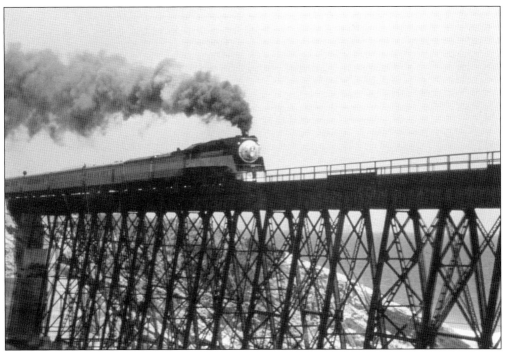

The *Coast Daylight* is racing north over the towering bridge at Goleta, with the Pacific Ocean in the background and a beautiful beach below. Beachgoers have a dramatic view. The train has been steadily climbing since leaving Santa Barbara, and the engine is working full throttle. Goleta is the last place northbound passengers will see the ocean. The Coast Route moves inland from here. (Paul C. Koehler Collection.)

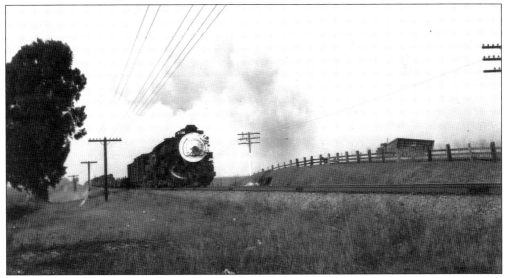

A Mountain-class locomotive powers a freight train running south on the Coast Route. The high bridge at Goleta is behind the train, while Santa Barbara with its small freight yard lies several miles ahead. The ocean is nearby, off to the left. The freight might pick up or drop cars off in Santa Barbara, but its ultimate destination is Southern Pacific's sprawling Taylor Yard in Los Angeles. (Paul C. Koehler Collection.)

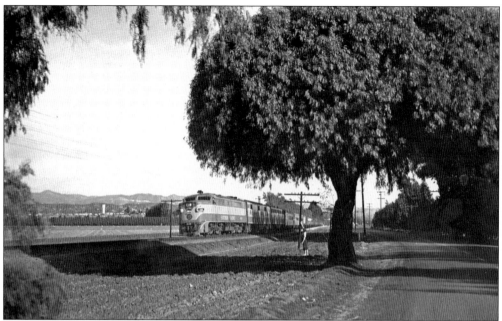

Southern Pacific train No. 99, the *Coast Daylight*, above, is in the care of a mixed set of engines as it races along East Fifth Street out of Camarillo toward Oxnard on its run to San Francisco in the late 1950s. Alco PA-3 6040 leads EMD E-7B 5902 and a late-model E-9A. The tall white structure in the left background is the control tower at Camarillo airport, later home base for the Corsair fighter planes used in filming the television series *Baa Baa Black Sheep*. Below, GS-5 4458 is just over two hours out of Los Angeles as it makes its stop at Santa Barbara. For a few passengers, Santa Barbara is their destination. More will board the train for its daylong run to San Francisco. (Southern Pacific photographs, Paul C. Koehler Collection.)

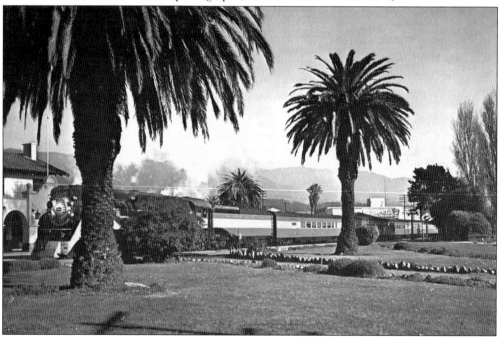

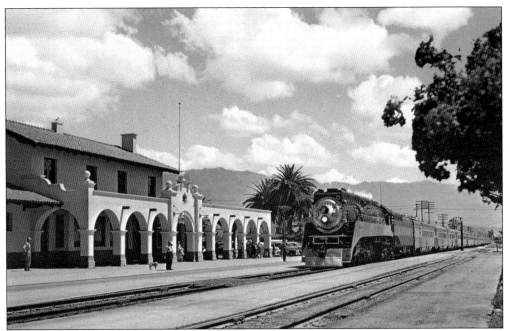

Perhaps realizing the palm trees in the previous photograph interfered with his shot, the photographer has moved to his left to get a clearer picture of GS-5 4458 and the handsome mission-style Santa Barbara station. Santa Barbara was a popular resort destination on its own, with wide, sandy beaches, a pier, fine hotels, and excellent restaurants. (Paul C. Koehler Collection.)

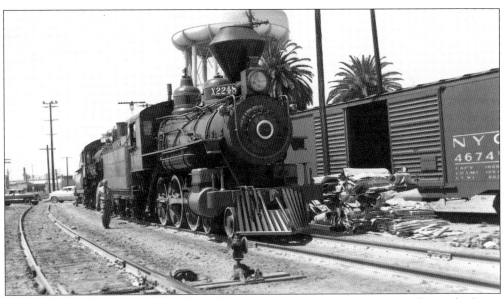

Ten-wheeler 2248 is seen at Oxnard on a fan trip from Los Angeles to Saugus and over the Santa Paula branch to Montalvo, then south back to L.A. The diamond stack was added for SP's 1955 Centennial. The engine survived the end of steam on the SP as well as a rollover during the 1971 Sylmar earthquake. It now operates in tourist train service on the State Railroad of Texas. (Paul C. Koehler Collection.)

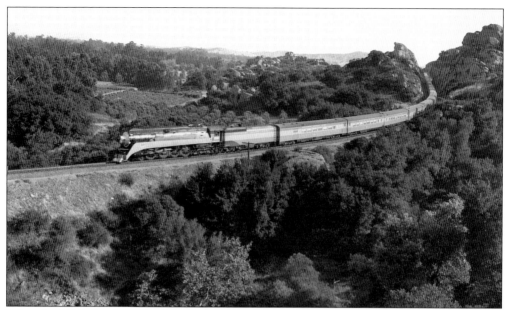

Behind a GS-4, the *Coast Daylight* snakes gracefully through the Chatsworth Rocks just west of Topanga Canyon Boulevard at the northern edge of Los Angeles' San Fernando Valley. Today's California Route 118, the Ronald Reagan Freeway, lies just over the hills immediately behind the train. The area is much more densely developed today. It was positively pastoral back in the 1940s. (Paul C. Koehler Collection.)

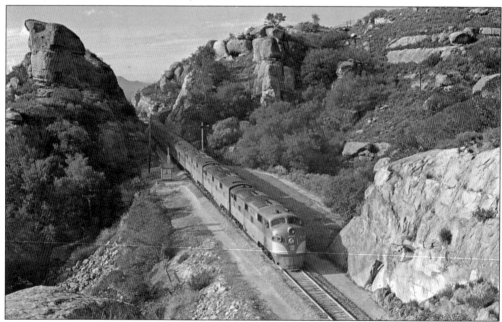

It must be summer, because it is early morning and the sun is well up as Southern Pacific EMD E-7 diesel units lead the *Lark* through the Santa Susana Mountains north of Los Angeles, sometime in the early 1950s. The engines wear the red and silver livery of the *Golden State*, but Southern Pacific pressed them into other service until streamlined cars for that train were delivered. (Southern Pacific photograph, Paul C. Koehler Collection.)

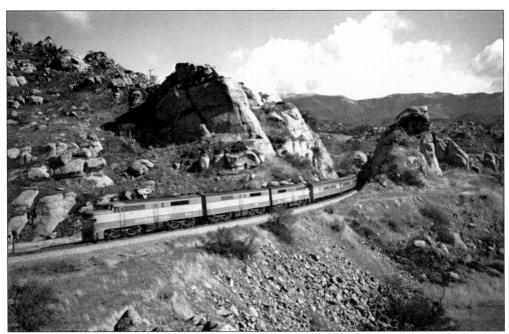

This is earthquake country, and the rugged and weathered Chatsworth hills, with their strongly tilted sedimentary rocks, betray the forces that literally move mountains in Southern California. The rocks make a striking background for train 99, the westbound *Coast Daylight*, as it grinds uphill behind a 6,000-horsepower set of handsome Alco PAs. (Southern Pacific photograph, Paul C. Koehler Collection.)

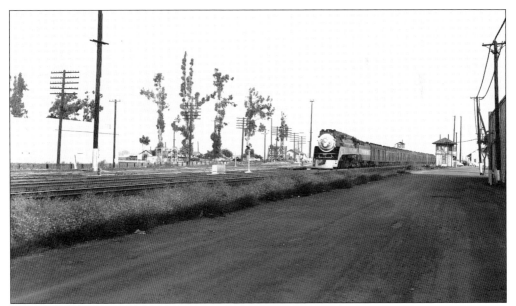

Train 71, the *Coast Mail*, is in the charge of a GS-4 as it heads north to San Francisco. Mail was a significant source of revenue for the Southern Pacific and most American railroads. The Post Office was very stringent in its regulations, specifying the exact size of the postal "apartment" in mail cars, the work rules, and even that postal agents be armed. (Paul C. Koehler Collection.)

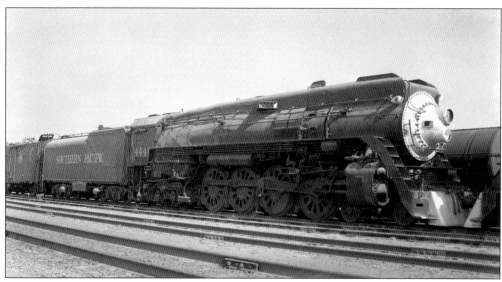

GS-4 4449 is the most famous, and one of only three survivors, of the powerful classes of GS engines that once roamed the Southern Pacific system. Like its kin, it at one time faced the scrapper's torch. In the photograph above, it lies idle in storage, its red and orange Daylight paint gone along with its streamlined side skirts. In 1958 the locomotive was donated to the city of Portland, and put on static display in a public park, where it was vandalized. The photograph below shows the engine as it was brought back to life for service in the red, white, and blue trim of the 1957 *American Freedom Train*. (Don Ball photographs, author collection.)

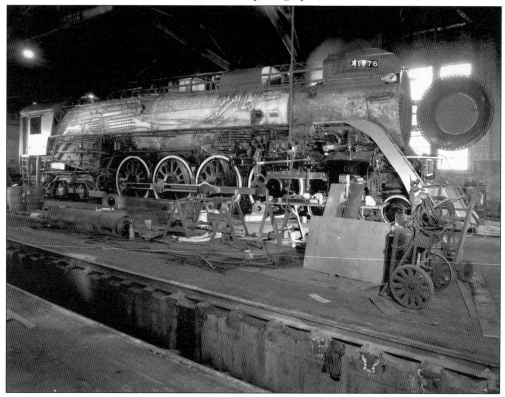

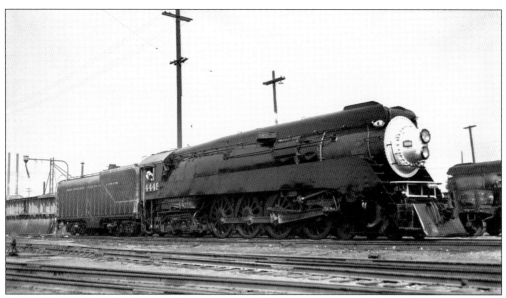

SP 4449 has its skirts back and a shiny new coat of black paint as a "war baby." Pre-1946 Southern Pacific Lines lettering is on the tender. Southern Pacific 4460, a GS-6, is on static display at the Museum of Transportation in St. Louis, Missouri. A St. Louis Southwestern (Cotton Belt) GS-8 engine is at the Arkansas Railroad Museum in Pine Bluff, Arkansas. (Don Ball photograph, author collection.)

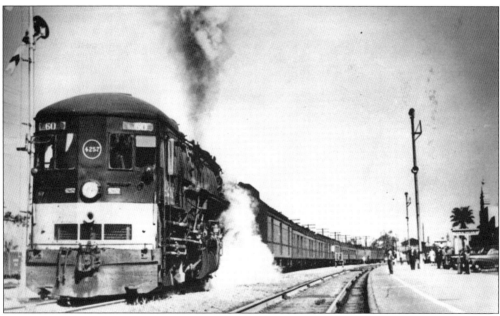

The Glendale, California, mission-style station is the last stop before Los Angeles for train No. 60, the *West Coast Passenger*. Always heavy with mail and express at the front end, the train runs overnight on the San Joaquin Valley Route between Los Angeles and Sacramento. Crews are changed at Bakersfield. (Paul C. Koehler Collection.)

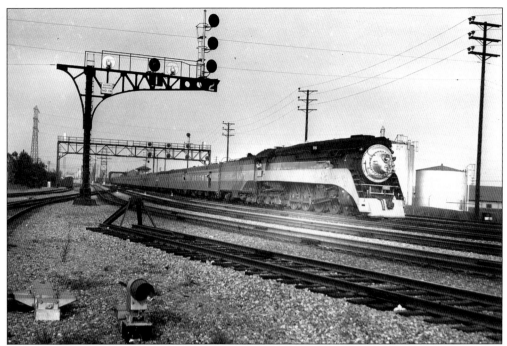

Train 98, the *Coast Daylight*, passes the signal bridges as it arrives at Los Angeles Union Passenger Terminal (LAUPT) behind a GS-4 in full Daylight livery. A clue shows the photograph was taken in the early 1950s: the locomotive's pilot is solid orange with no chrome strips. The railroad was keeping up appearances, but going to no more maintenance trouble than absolutely necessary. (Paul C. Koehler Collection.)

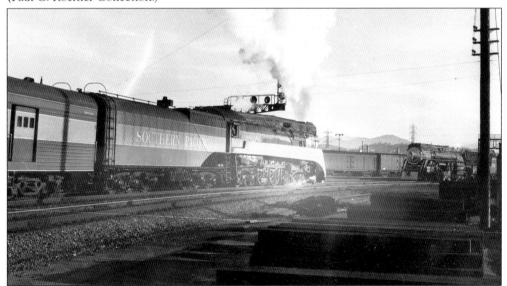

The morning sun gleams on the flanks of the *Coast Daylight* as it departs Los Angeles Union Passenger Terminal between Terminal Tower and Mission Tower. The engine is 4459, one of the GS-5s with roller bearings on its axles and drive gear. Another, de-skirted GS engine is at right. The cars in the background between the two engines are express refrigerators, used for high-value perishables. (Paul C. Koehler Collection.)

Four
THE VALLEY, THE TEHACHAPIS, AND LOS ANGELES

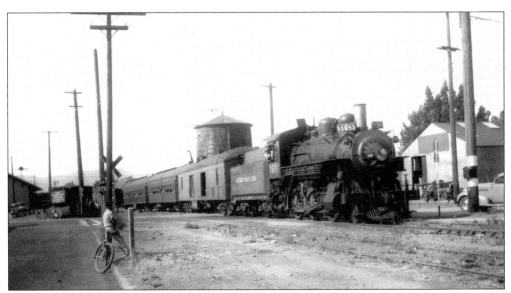

A boy, a bike, a steam engine with its friendly engineer, a big wooden water tank, and a bunch of pre-war automobiles—what more could be asked from a railroad photograph? In a classic scene that could almost come from a movie, Mogul 1685 pulls a two-car excursion train through a small Central California town not long before World War II. (Paul C. Koehler Collection.)

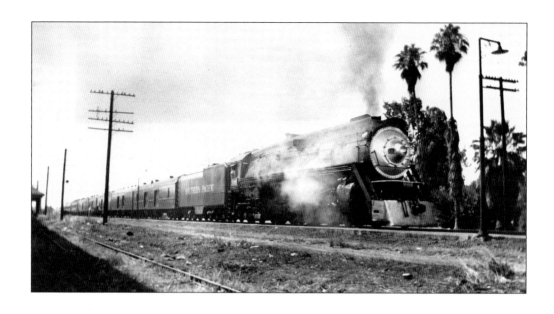

Train 55 (above), the *Tehachapi*, the San Joaquin Valley mail train, is not long out of Los Angeles, en route to Oakland. Mail trains were slow and heavy, with frequent stops to pick up and drop off mail and express. A GS-6 is on the point. In the photograph below, the *Tehachapi* is much farther along its route up the San Joaquin Valley, running at track speed on a level grade as it crosses Santa Fe rails between Bakersfield and Fresno. Mail and express was an important part of Southern Pacific's business, but in the fall of 1967, the U.S. Postal Service cancelled most of its railroad contracts, ending a vital source of revenue for passenger service. (Both photographs, Paul C. Koehler Collection.)

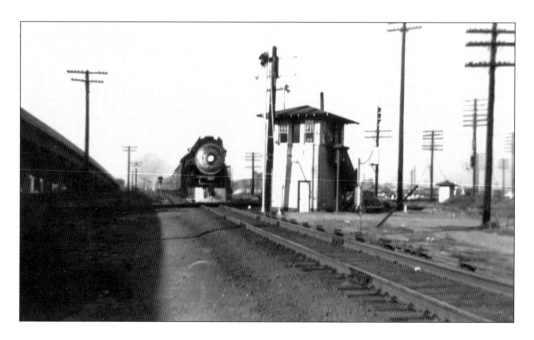

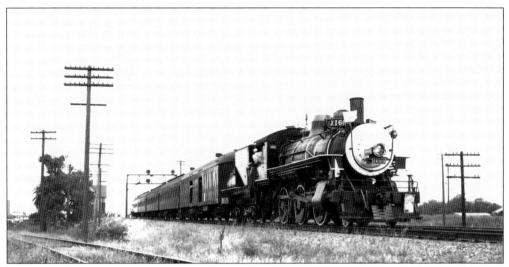

Mogul 1660 is dolled up in its shiny Sunday best for an excursion run, possibly around Tracy. The engineer is leaning out of the cab, facing the rear of the train as he makes a reverse move. He will back his train down so it can pick up passengers who disembarked to photograph a run by. The engineer made sure to make plenty of smoke and steam for the photographers. (Paul C. Koehler Collection.)

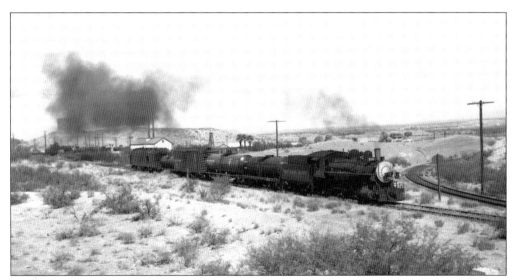

In the days before good roads, the classic mixed train reliably served rural communities. Passengers and packages rode in the combine, with freight in the boxcars. Fuel and lubricants came to local distributors in tank cars. The first tank car probably carries extra water for the little Mogul rambling back from a jaunt on the branch line to rejoin the main, curving away at right. (Paul C. Koehler Collection.)

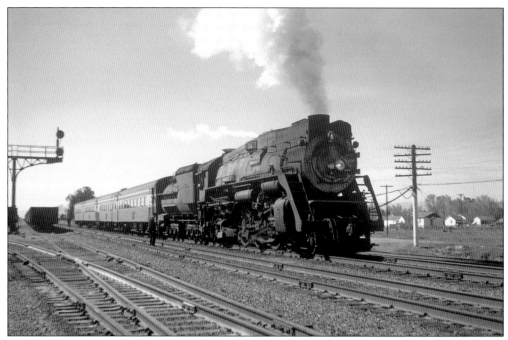

This pair of photographs shows a very handsome little train, the *Sacramento Daylight* (above), in the act of adding its connecting cars (below) to the southbound *San Joaquin Daylight*, at right rear. The exchange was made with both north and southbound trains seven days a week. The train was hugely popular with legislators and lobbyists in the days before airplane flights were common and road travel was arduous. The *Sacramento Daylight* trains were pulled by P-10 Pacifics, the heaviest on the SP roster. The engines were originally painted in the full Daylight livery, with skirts, and then in a skirtless Daylight cab and tender scheme only. By the time of these photographs, even the plain black paint could use a new coat. (Alden A. Armstrong photographs.)

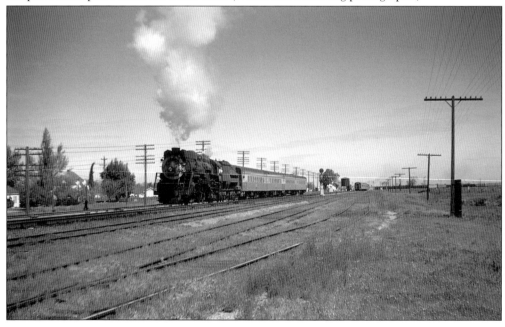

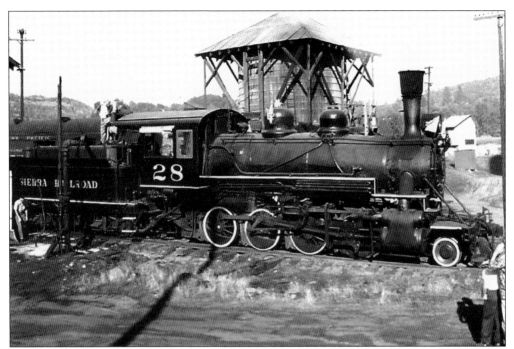

The Sierra Railroad served the gold country in the Sierra foothills connecting to the Southern Pacific at Oakdale. Photographer Gary Jones writes, "In 1959 I only had a box camera and talked my dad into taking me on a Sierra RR excursion. Once the engine was serviced, it recoupled to its train and proceeded on to Sonora and eventually Oakdale, where the trip began that morning." (Gary B. Jones photograph.)

In this 1916 view of Merced's M Street, the crossing arms are up and a horse-drawn wagon has just crossed over the tracks, leaving small ruts in the unpaved street but no signs of horse pollution. There is a "STOP" sign for this crossing, along with a removable sign under it reading "WATCHMAN ABSENT." All the other vehicles in sight are motor-driven. (Gary B. Jones photograph.)

Here is just a few minutes later than the photograph on the preceding page. The crossing watchman has returned and stands outside his second-floor door on a small balcony, watching as several pedestrians cross the Southern Pacific tracks on M Street in Merced in 1916. At the approach of a train, he will lower the eight (four are for pedestrians) electrically powered gate

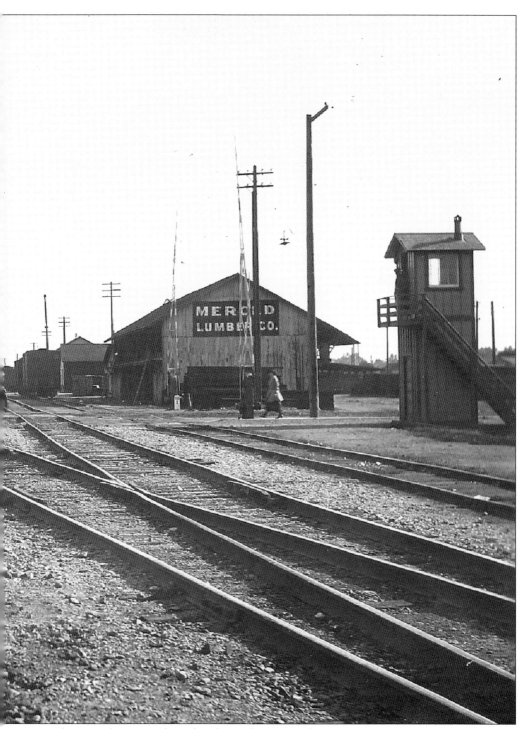

arms. The semaphore signal on the elevated signal bridge in the left middle distance depicts a stop aspect for southbound trains, protecting a steam locomotive just visible on the mainline track to the south. The Union Pacific Railroad's mainline occupies this location now and everything else in this photograph has been gone for decades. (Gary B. Jones photograph.)

Southern Pacific's westbound *San Joaquin Daylight* has departed Modesto on a March afternoon in 1967. The locomotives of freight train X6463 East are stopped on the switch but cannot return to the mainline until the track switch is lined. The brakeman has opened the electric switch lock case and waits for it to release before he throws the controlling lever on the switch stand to his left. (Gary B. Jones photograph.)

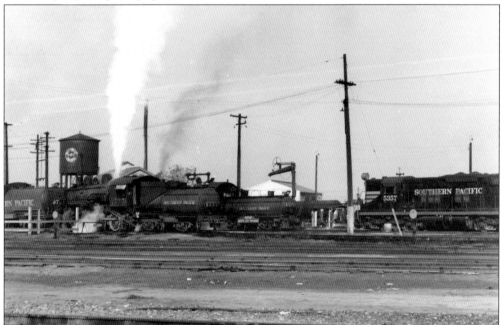

It is late in the day for steam engines on the Southern Pacific, but several are still active in this view of the Fresno roundhouse. Road diesels like SD-7 5357, with its ash can headlights, will replace the heavy steam road power, the cab-forwards and 2-10-2s. Ironically, the older, smaller engines like Mogul 1777 will survive longest, thanks to their ability to operate on the light rail of branch lines. (Paul C. Koehler Collection.)

One of Southern Pacific's classic tall 10-wheelers (4-6-0), No. 2105, has a short train in tow in this busy scene from sometime after the 1946 relettering to Southern Pacific instead of Southern Pacific Lines. Despite its brevity, the local has captured the attention of trainmen as passengers board and clerks load mail and express in the RPO car, perhaps from the Railway Express Agency truck at center. (Paul C. Koehler Collection.)

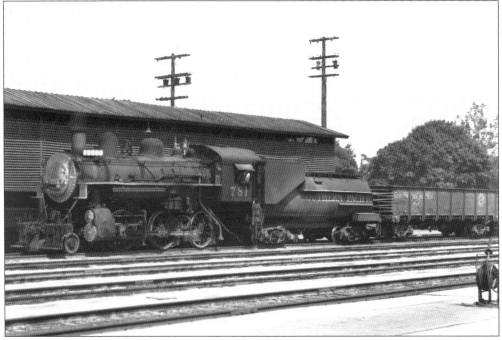

A "tea kettle," little M-6 Mogul 1781 simmers away in Bakersfield, immediately across from the depot, in front of the private passenger car shed, which was used to shelter cars from the San Joaquin Valley heat. Make no mistake, it was still plenty hot under the shed, but nowhere near as hot as the all-steel cars could get under direct sunshine. (Milt Harker photograph.)

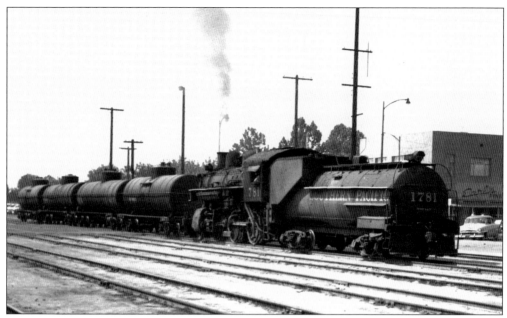

It is just another day at work for Mogul 1781, shoving four tanks of fuel oil from the roundhouse at Bakersfield to Oil Junction, some 4.5 miles north. The Kern County oil fields were important to both the Southern Pacific and the Santa Fe as a source of business revenue from hauling the raw and finished products and as a source of fuel oil for their locomotives. (Milt Harker photograph.)

Locomotion got even more basic than Moguls on the Southern Pacific. In fact, this speeder is about one step up from a handcar, but a significant improvement for members of the track and signal gangs that used them like the army used jeeps. In theory, speeders came equipped with rudimentary cloth tops. In reality, they got lost more often than not. (Milt Harker photograph.)

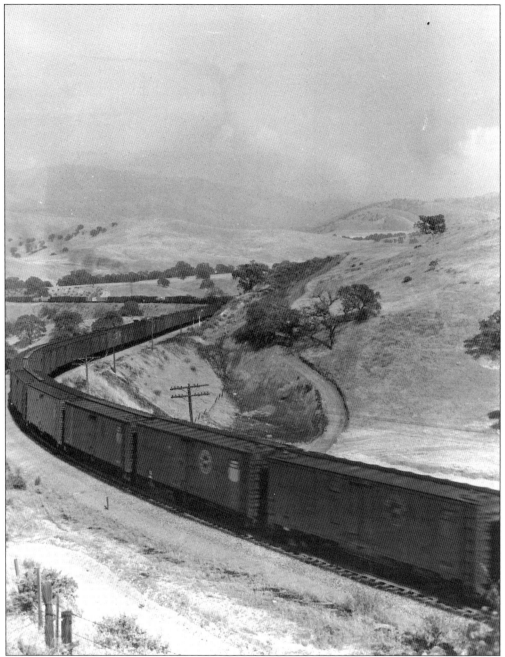

A westbound block of iced Pacific Fruit Express refrigerator cars from Los Angeles comes down off the Tehachapi Mountains and prepares to sweep left into the horseshoe curve at Caliente for the run down Caliente Creek toward Bakersfield. The Southern Pacific's route down the San Joaquin Valley originally ended a bit south of Bakersfield. The rugged Tehachapis were considered uncrossable, because of steep grades, until engineers Austin De Wint Foote and William Hood devised the loop in 1876. The loop, beguilingly like a child's Christmas tree layout, was a stroke of engineering genius, significantly lowering the grade and making the Tehachapis passable. (Paul C. Koehler Collection.)

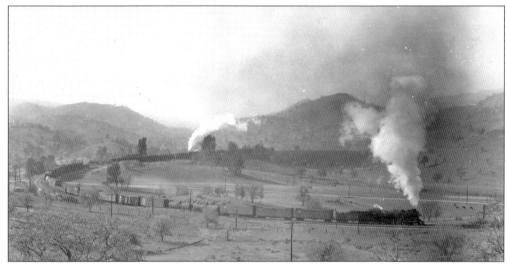

The loop is a spiral of track just a bit less than 0.75 miles long. Thus, trains longer than that will actually pass back over (or under) themselves, with the upper track 77 feet above the lower. In 1998, it was recognized as a National Historic Civil Engineering Landmark. In the days of steam (above), trains crossing the Tehachapis would often have a cab-forward on point, another about two-thirds of the way back, and yet another pushing behind the caboose. In the diesel era (below) road engines and helpers are distributed in the same pattern. The location of the loop is known as Walong, named in honor of Southern Pacific district roadmaster W. A. Long, with a passing siding. A working ranch neighbors the loop. (Paul C. Koehler Collection.)

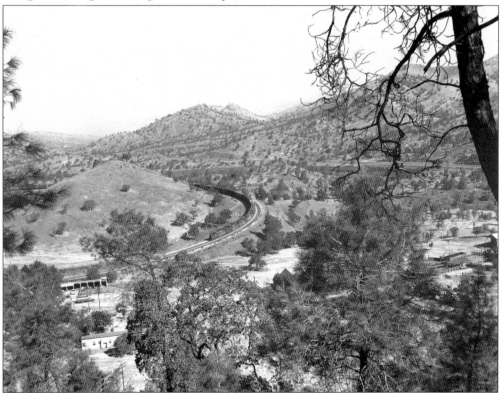

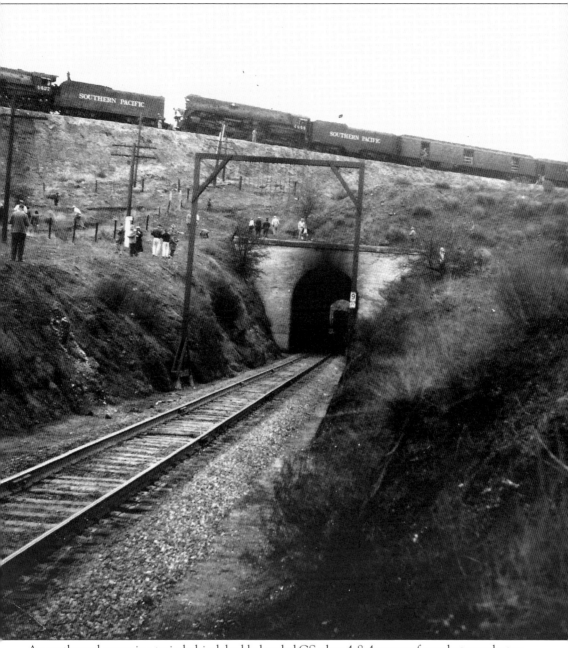

An eastbound excursion train behind double-headed GS-class 4-8-4s pauses for a photograph stop at the crossover point on the Tehachapi loop. The passengers are scattered across the hillside, photographing one of the most famous scenes in American railroading. A close look reveals a caboose in the tunnel, trailing an westbound freight train, which passed the excursion while all the sightseers were on the ground, some of them standing over the tunnel. Safety experts (nannies) from the modern era would be beside themselves with apoplexy, as would the railroad's insurance agents. As icing on the devil-may-care cake, where the photographer had to be standing to snap this picture must be considered. Today, anyone who so much as walks on the property will be arrested by Union Pacific or Burlington Northern. (Paul C. Koehler Collection.)

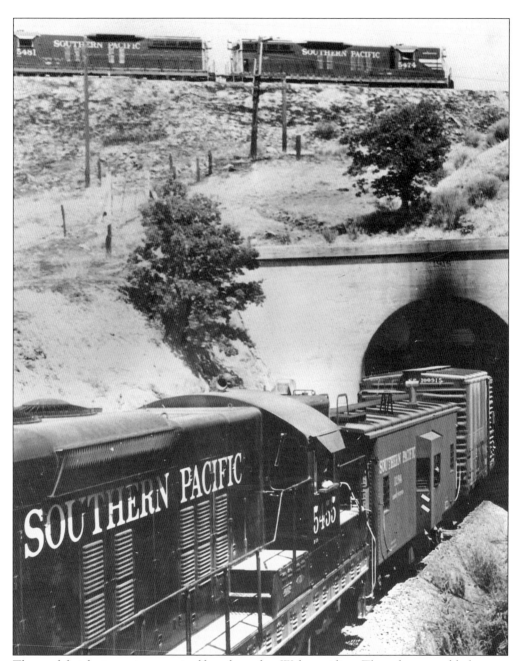

The road freight is passing over itself eastbound at Walong siding. The caboose and helper are actually on the rear end of the train pulled by the SD-9s above. The tunnel is known as Tunnel Nine, because it was originally the ninth tunnel on the route from Bakersfield. Many of the tunnels on either side of the loop have since been "daylighted," or opened up, especially after the 1952 magnitude 7.5 Tehachapi earthquake. The United States Geological Survey said it was the largest quake in the lower 48 since the 1906 San Francisco shock. The maximum intensity was at a portion of the railroad southeast of Bealville. There, the earthquake cracked 18-inch thick reinforced-concrete tunnels. It also shortened the distance between portals of two tunnels about 8 feet and bent the rails into S-curves. (Paul C. Koehler Collection.)

Five

THE SP NARROW GAUGE, THE SDA&E, AND PACIFIC ELECTRIC

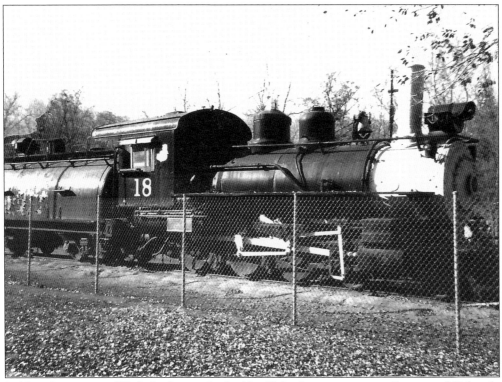

Baldwin Locomotive Works built ten-wheeler No. 18 for the narrow gauge Carson and Colorado Railroad (C&C) in 1917. The 44-ton locomotive became the property of the Southern Pacific when the SP acquired the line from parent Virginia and Truckee. The little engine, and two companions, operated over what was formally known as SP's Keeler Branch, in California's remote Owens Valley, an alpine desert between the snow-capped Sierra Nevada and the much drier Inyo and White Mountains. Locomotive No. 18 was retired in 1954, when SP's one and only narrow gauge diesel was purchased. It now sits forlornly behind cheap chain-link fencing in a public park in Independence, the seat of Inyo County. (Paul C. Koehler Collection.)

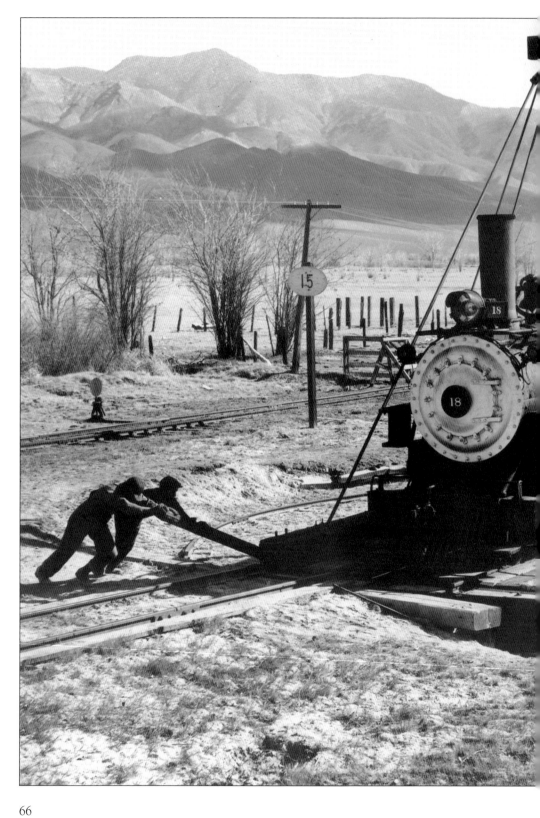

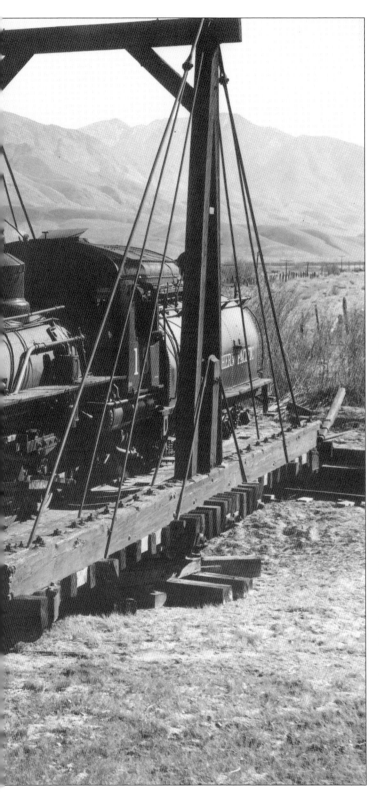

Anyone who wants to know what "work" is should take a good look at this February 7, 1951, photograph. No 18's 44 tons of steel, 88,000 pounds, are balanced on a wooden turntable at Laws, on the Keeler Branch. The two railroaders at left are going to walk the engine halfway around the turntable pit, thus reversing its direction. This is called the Armstrong method, something of a misnomer because the men are putting their backs and legs into the job. Laws was the north end of the Keeler Branch, after the Nevada trackage had been torn up. Although built by the C&C to haul silver ore from the Comstock Lode, the engines working the Keeler Branch spent most of their working lives hauling less dramatic minerals, primarily talc. (Author collection.)

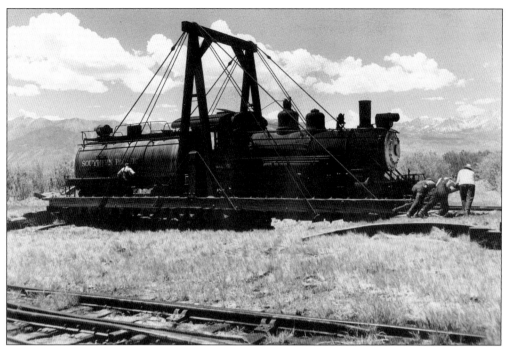

In this June 1, 1950, photograph, three men are on the Armstrong bar, and a fourth, possibly engineer Walter C. Ferguson, stands by the tender. Narrow gauge employees worked long, hard hours in the high desert's blistering summers and icy winters. Their duties carried them from one end to the other of the 70-mile Keeler Branch, the remnant of a railroad once some 300 miles long. (Author collection.)

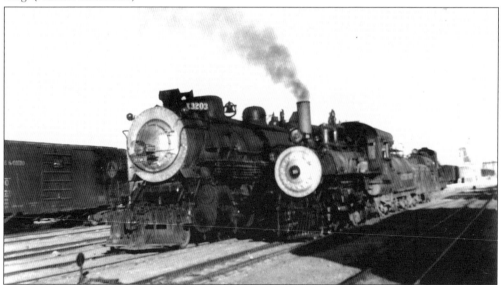

The narrow gauge interchanged with the Southern Pacific standard gauge at Owenyo, virtually in the shadow of Mt. Whitney, the tallest peak in the lower 48 states. Mikado 3203 sits next to one of the narrow gauge engines, which in turn is pulling a flatcar with yet another narrow gauge engine on it. The diminutive engines were sent to Bakersfield for major shopping. (Paul C. Koehler Collection.)

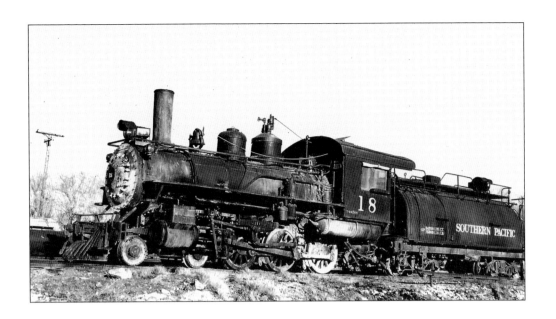

No. 18 (above) is looking a little bedraggled in this undated photograph. The Keeler Branch's engines spent their days outdoors, with even the engine service facilities at Keeler in the open air. The combination of year-round bright sun, blowing sand, and alkali water took their toll. It was only when the engines were shopped in Bakersfield that they were repainted. No. 9 (below) is on its way to Bakersfield for overhaul. At Owenyo, the small engines climbed a ramp and rolled onto a standard gauge flatcar, for inclusion in a Jawbone Branch train to Mojave. There, the flat would be switched out, added to a westbound freight, and dropped at the Bakersfield roundhouse, which had its own ramp and section of narrow gauge track. (Paul C. Koehler Collection.)

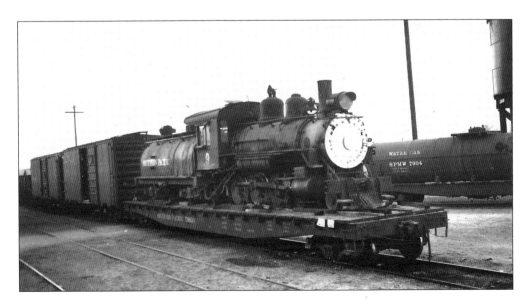

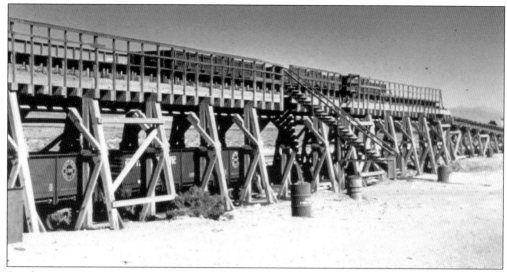

Southern Pacific completed its Jawbone Branch from Mojave north to the Owens Valley in 1910, linking its standard gauge line with its narrow gauge at Owenyo. The Owens Valley, overshadowed by the towering Sierra Nevada to the west, was rich in mineral resources. Interchange facilities, including this over and under bulk mineral transfer dock, were built along with a depot and a hotel. (Paul C. Koehler Collection.)

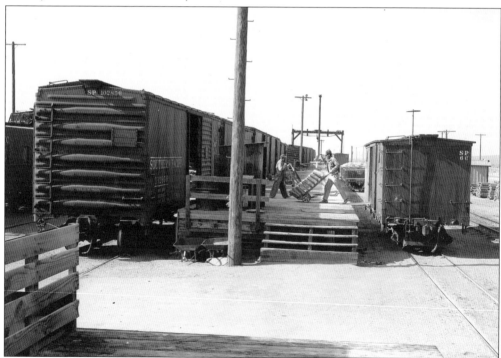

Some minerals, especially talc, soda ash, and dolomite, were shipped in sacks variously reported to weigh 50 to 100 pounds. The car-to-car transfer dock at Owenyo is sloped between the smaller, lower narrow gauge cars and the higher standard gauge cars. That means the porter in the photograph, with nine sacks on his hand truck, is pushing no less than 450 pounds uphill. (Paul C. Koehler Collection.)

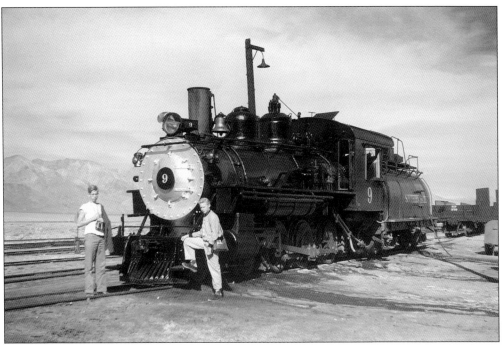

No. 9 was the last SP narrow gauge steam engine to run in revenue service, and its last day of revenue operation was August 25, 1959. No. 9 was in the spotlight earlier on October 16, 1954, for the last "official" steam run on the narrow gauge, when diesel No. 1 was dedicated. Photographer Alden Armstrong (above left) and friend Vernon Thurgood were on hand for the occasion, after riding a steam special powered by double-headed 4-6-0s up the Jawbone from Mojave to Owenyo. The engine was soon coupled to a train that would make OSHA wince, which spent several hours whistling, chuffing, squealing, and rattling across the desert floor. Sad to say, locomotive engineer Ferguson did not outlast his beloved teakettles by all that much. He died in 1962. (Jeanette Armstrong photographs, both courtesy Alden A. Armstrong.)

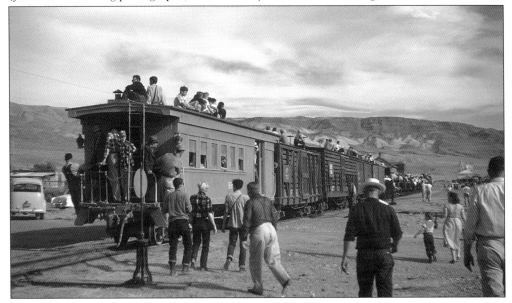

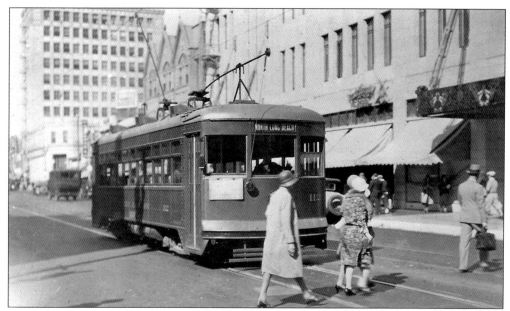

Pacific Electric trolley No. 112, purchased in 1930, was one of 15 cars in its class, the last new city cars the Southern Pacific subsidiary bought. Built by the Saint Louis Car Company, the 100-class cars were ideally suited for lighter local runs. Eight were initially assigned to the East Long Beach–North Long Beach (Willow Street) line, with the balance of the class sent to the Orange Empire. (Paul C. Koehler Collection.)

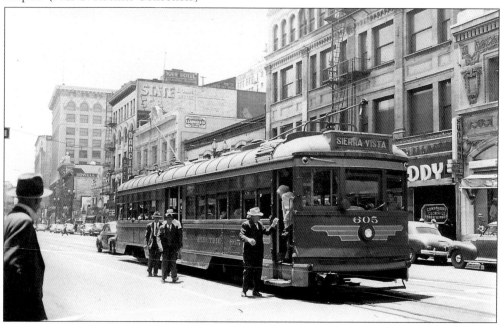

Pacific Electric (PE) car number 605 is one of the first Hollywood cars, so named for their initial service on Hollywood Boulevard. The 160 cars formed PE's largest class and its longest-lasting, ultimately seeing service over much of the system. On this day, No 605 is in Pasadena on Colorado Boulevard near Fair Oaks Boulevard, inbound for Sierra Vista in East Pasadena. (Paul C. Koehler Collection.)

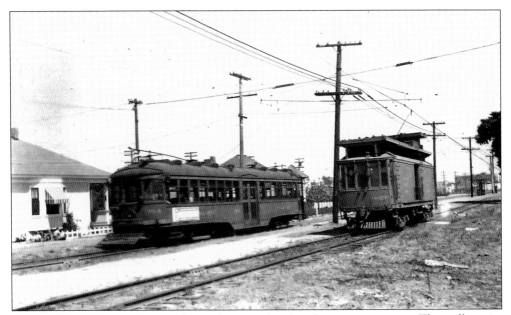

Pacific Electric's prosperity varied over the years, but frugality was a constant. The trolley wire was always maintained, but the right of way was often lightly ballasted and weed-grown. The 700-series Watts car at left sports an Elipse "peoplecatcher" fender, while the wooden tower car at right has been rebuilt from an earlier car. (Paul C. Koehler Collection.)

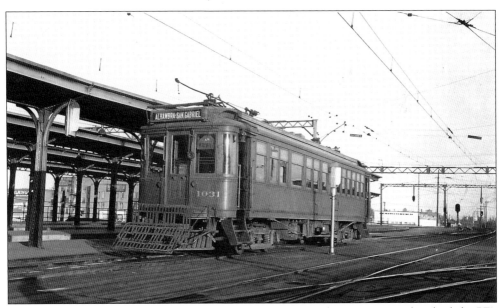

The first 1000-class cars, known as Tens, arrived in 1913 and were extensively rebuilt by PE's versatile Torrance Shops over their service lives. This car has arrived at PE's Fifth and Main terminal in downtown Los Angeles and debarked its passengers. No. 1031 is one of the cars originally delivered with toilets at the center of the car, but the convenience was removed during rebuilds. (Paul C. Koehler Collection.)

Pacific Electric had two 4-track mainlines. One ran along Huntington Drive in the San Gabriel Valley, the other ran from downtown Los Angeles to San Pedro. The San Pedro route, with its much denser freight traffic and extensive passenger service, was much busier. In this photograph, the two-car train is at Slauson Boulevard, passing an odd assortment of buildings, headed for San Pedro. (Paul C. Koehler Collection.)

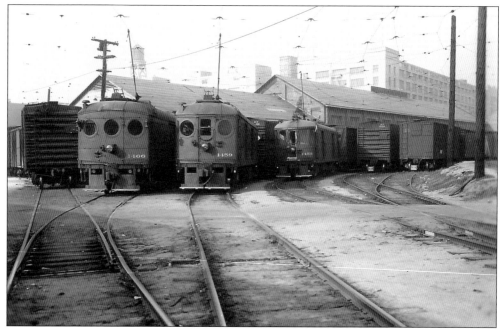

Pacific Electric had an extensive fleet of freight motors, along with mail and express cars. The freight box motors were routinely worked out of the freight shed at PE's Eighth Street yard, located at Eighth and Alameda Streets. Car 1466 was an import from SP's Bay area operations to help meets the freight demands of World War II. No. 1459 came from Portland, while 1455 was home-built for express service. (Paul C. Koehler Collection.)

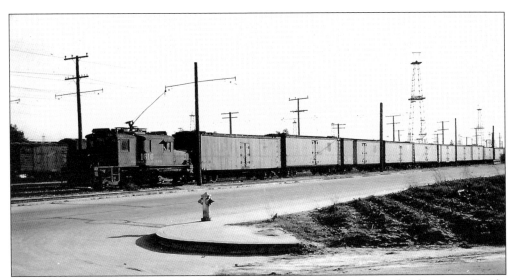

Engine 1616 and sibling 1617 were the last of the Baldwin-Westinghouse freight motors Pacific Electric bought new, and were considered hauling fools. These locomotives were painted a dark red when new, then went to black with white trim in 1944, with orange tiger stripes added in 1949. In this shot, Engine 1616 is working down around Watson yard, lugging an inbound banana train up from the docks. (Paul C. Koehler Collection.)

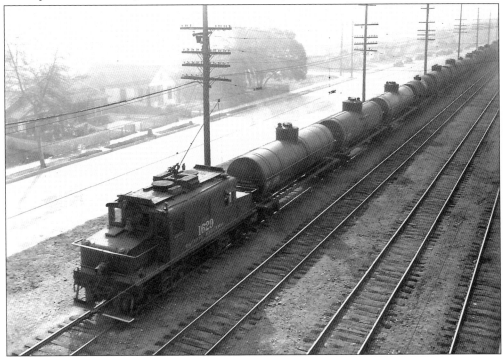

Frugal Pacific Electric was upset by the price of factory-built freight motors 1616 and 1617, so it rolled its own for later orders. Engine 1620, a home-built product of the Torrance Shops, is in charge of the Standard Oil tank train, inbound on the four-track main, bound from El Segundo to Los Angeles. It is possible this is just a hazy day, but a better bet is that it is eye-searing smog. (Paul C. Koehler Collection.)

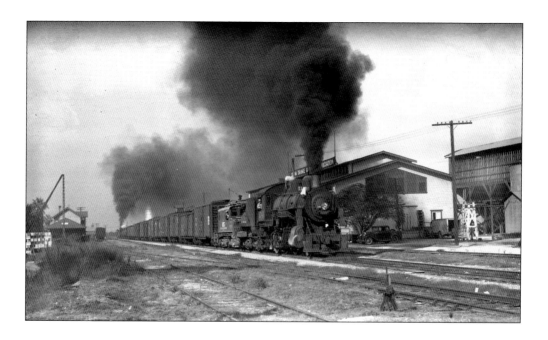

The traffic demands of World War II left Pacific Electric short of power, leading it to borrow steam engines from parent Southern Pacific. The steamers lead PE engines with trolleys in order to activate PE's signals. Above, SP Mogul 1740 leads a train past the Corona Orange Growers Association warehouse, with PE motor 1625 behind, and yet another Mogul shoving on the rear. In the photograph below, the same two engines are working a good-sized mixed freight, but the rear helper is missing. The vineyards at left and left rear background plus the San Gabriel Mountains, right background, indicate the train is going about its business in the Ontario area, possibly en route to San Bernardino. (Don Ball photographs, author collection.)

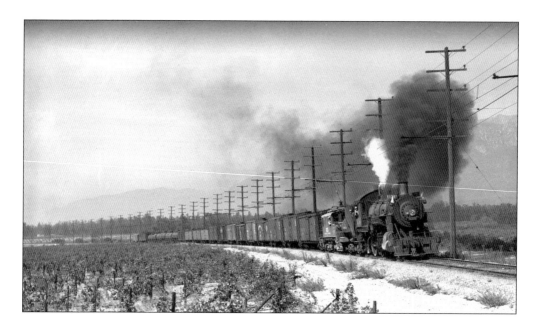

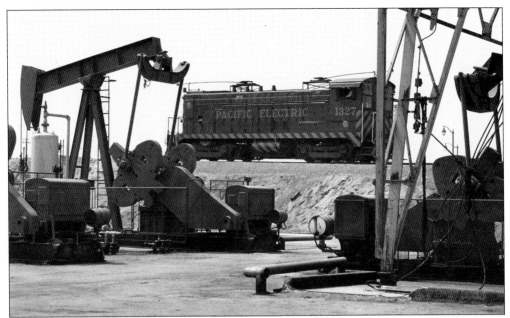

Pacific Electric engines 1327 and 1328 are sisters, both 120-ton 1,000-horsepower Baldwins, but they are dressed a bit differently. 1327, above, framed by oil-well pumps, sports a pair of signal-activating trolley poles, both of them down in this instance. Engine 1328, working the pier outside Berth 179, the Port of Los Angeles, in Wilmington, appears to be entirely without trolley poles. The rigging of the ship in the background makes it difficult to tell, but a trolley pole platform seems to be in place just ahead of the cab. Pacific Electric made extensive use of freight diesels after the Second World War up until the merger with Southern Pacific in 1965. (Both photographs, Paul C. Koehler Collection.)

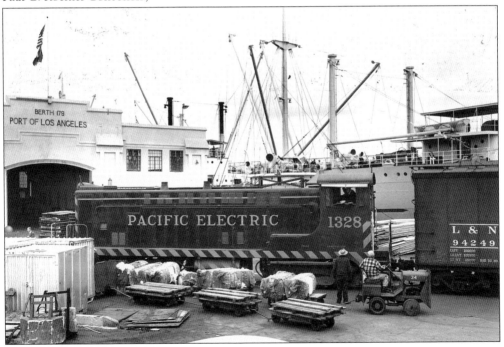

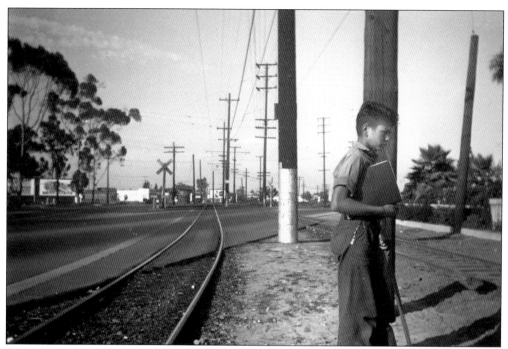

This sequence of photographs comes from Donald R. "Doctor" Latham, a Southern Pacific engineer who died in 1990 in Los Angeles. It is an open question whether Don took the pictures or is in them. In any case, they are about young boys fascinated by trains and the Red Cars of the Pacific Electric. In the first shot (above) a somber boy has a stick and a notebook, perhaps for recording his observations. It is difficult to tell, but he certainly is serious about something. In the photograph below, two boys, both seemingly deeply absorbed, wait in one of PE's rudimentary shelters. The wire for paired PE tracks curves away at left, while the diamond of a steam railroad crossing is at center. (Donald R. Latham, courtesy Dick and Leeanne Curts.)

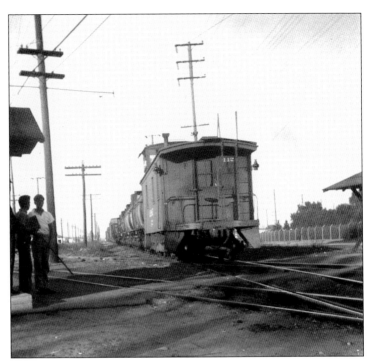

In the final photograph of the series, a Southern Pacific train passes the boy with the book and stick and his white-shirted companion. From other Don Latham photos, it is known the pictures were snapped sometime before World War II, and somewhere near Terminal Island. Perhaps it is all nothing more than a day of trainspotting in Southern California, but that is a good day for a boy. (Donald R. Latham photograph, courtesy Dick and Leeanne Curts.)

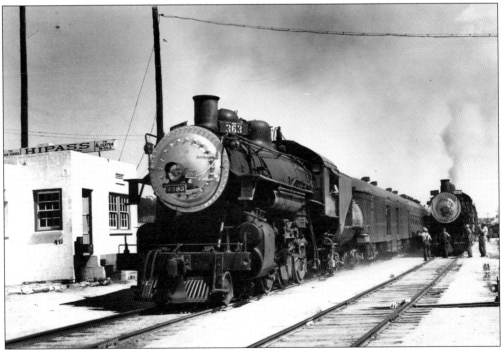

Train 363, a westbound passenger, passes westbound freight No. 457 at Hipass on the San Diego and Arizona Eastern on September 25, 1947. The SD&AE is a Southern Pacific subsidiary originally built by the Spreckles sugar interests, with a route that takes it into Mexico. As the name implies, Hipass is the highest point on the railroad, at an altitude of 3,660 feet. (Paul C. Koehler Collection.)

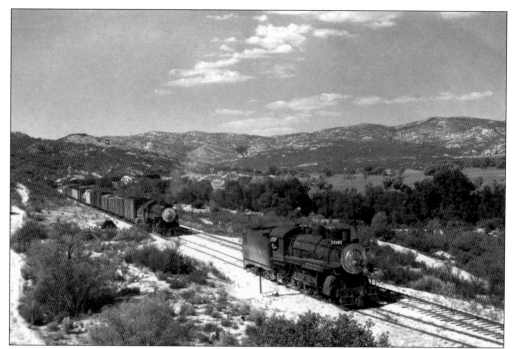

SD&AE train 451, a westbound freight, pauses at Clover Flat on that same September 25 in 1947. Eastbound freight No. 452 has just passed, and helper 2343 has cut off and will either stand by to assist an eastbound or will return light to the helper station at Coyote Wells. The route from Clover Flat to Coyote Wells was, at minimum, steep and curving, with helpers needed to assist SD&AE's small engines. (Paul C. Koehler Collection.)

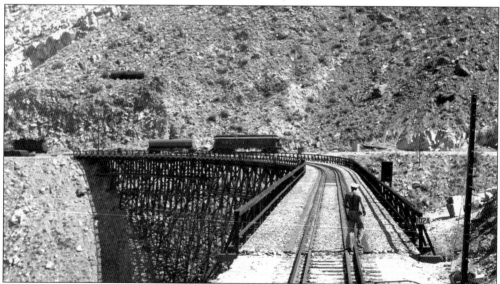

Goat Trestle is the attraction in remote but spectacular Carrizo Gorge on the San Diego and Arizona Eastern. It is 1947, and the shirtless man is a reminder that many war veterans used bits of old uniform as work clothing. The tank car in the background is on permanent fire duty, and the old coach is a maintenance of way car, possibly the bunk house for the bridge sentry and track workers. (Paul C. Koehler Collection.)

Six
THE SOUTHERN PACIFIC AT WAR

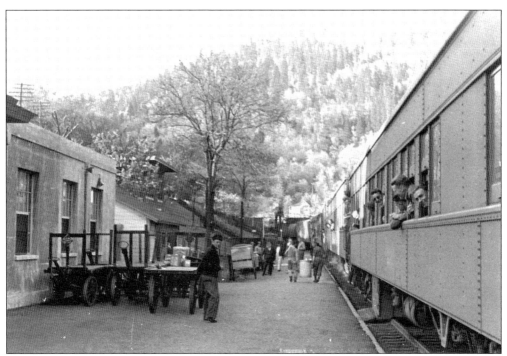

In April 1945, a troop train en route to Fort Lewis, Washington, pauses at Dunsmuir. Capt. Martyn J. Hodes, who snapped the photograph, notes: "I was headed for the invasion of Okinawa. Actually, I never got beyond Honolulu, which disappointed me at the time, but now stands out as the luckiest thing that ever happened to me. I had overseas service that was like the vacations that Matson Lines advertised." (Martyn J. Hodes photograph, Paul C. Koehler Collection.)

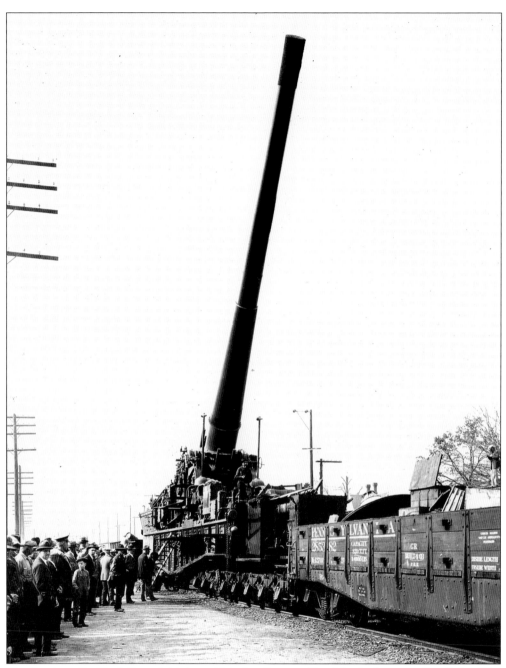

The Southern Pacific delivered this huge 14-inch rail gun to Fort MacArthur, near San Pedro. The guns, the army's largest mobile ordnance, were derived from the same 14-inch naval rifles fitted to Arizona-class battleships, and were used for coastal defense before, during, and after World War II. This particular gun was test-fired above Gaviota on SP's Coast Line. A similar set of rifles was emplaced near the Golden Gate Bridge. None of them was ever fired in wartime, although antiaircraft guns were fired in Los Angeles during a false alarm in February 1942, when a worried population and its defenders were expecting a Japanese attack. A Coast Artillery Brigade fired over 1,400 shells, killing three people on the ground. (Paul C. Koehler Collection.)

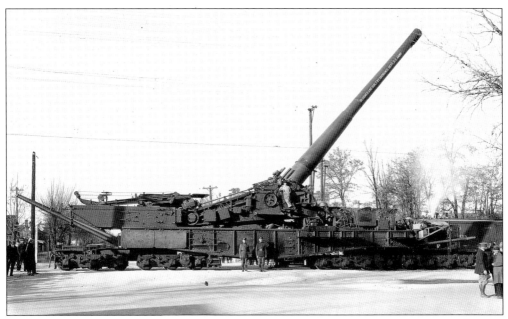

This side view of the same gun shows how big these rifles were. It is mounted on a specially built railcar with 14 pairs of wheels. The gun and carriage stand 14-feet-1-inch tall, with a total length of 95 feet, 4 inches. The unit weighed in at a hefty 365 tons. The officers standing at attention contrast with the SP trainman lounging next to the rifle's breech. (Paul C. Koehler Collection.)

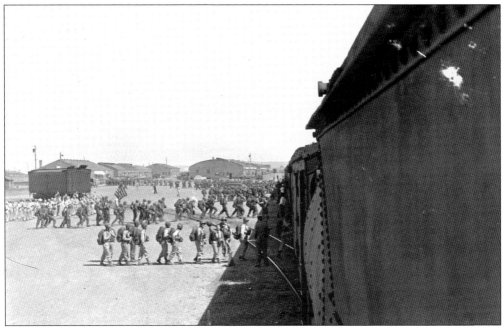

Troops board a Military Main train, a troop train, at Camp Beale in Northern California. The soldiers are outfitted in full combat gear. Their duffel bags, with spare clothing, have been loaded into the train's baggage cars. The train includes boxcar-like troop sleepers and kitchen cars plus regular heavyweight Pullman cars for the officers and soldiers. (Paul C. Koehler Collection.)

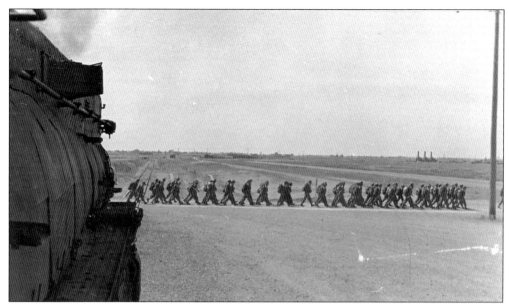

Another file of soldiers passes in front of the troop train locomotive, marching to their point of embarkation. During the Second World War, Camp Beale served as the training ground for the 13th Armored as well as the 81st and 96th Infantry Divisions. It also served as a prisoner-of-war camp for captured German soldiers. Later, as an air force base, Beale hosted squadrons of U-2 and SR-71 reconnaissance aircraft. (Martyn J. Hodes photograph, Paul C. Koehler Collection.)

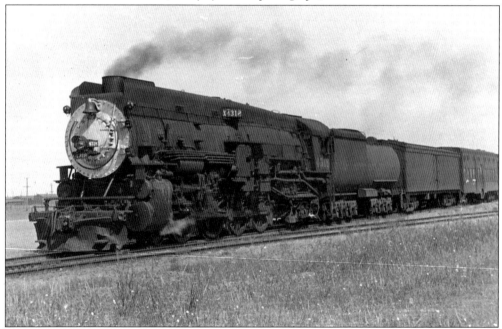

Southern Pacific Mountain 4318 is on the point of the troop train. The first car is an express refrigerator car carrying fresh provisions for the kitchen cars. All meals en route to Fort Lewis will be served aboard the train. The third car appears to be a troop sleeper, with the fifth car a kitchen car, which shared the same overall construction but had a different window arrangement. (Martyn J. Hodes photograph, Paul C. Koehler Collection.)

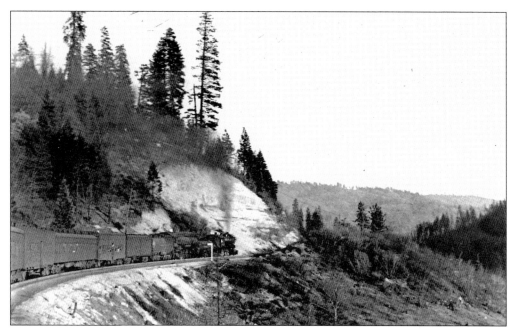

Mountain 4318 has acquired a helper for the climb up the canyon of the Sacramento River. On a clear day, Mt. Shasta would be visible to the right of the northbound train. Camp Beale trained over 60,000 soldiers during the war; most, if not all, of them bound for the Pacific campaign. The officers on this train knew they had orders for Okinawa, but it is doubtful the troops knew that. While the Port of Oakland was closer to Camp Beale, it was very busy. Many troops shipped out from Seattle or Tacoma. Still others shipped out of Los Angeles and Long Beach, with marines departing from San Diego. (Martyn J. Hodes photograph, Paul C. Koehler Collection.)

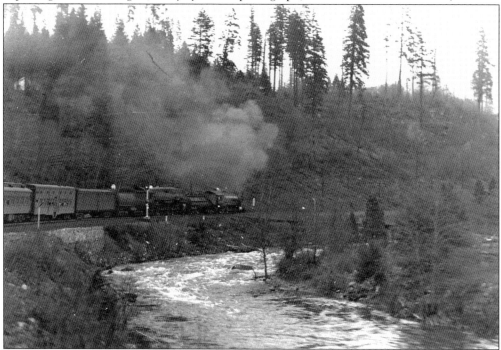

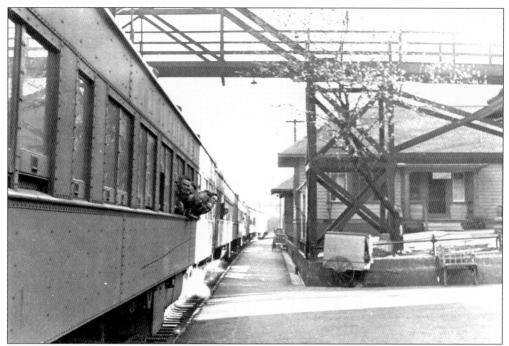

As the troop train stops for water at Dunsmuir, grinning soldiers lean out of their car and mug for the camera. At many stations, civic groups would bring coffee and snacks for the troops. The footbridge over to the working part of the yard is seen above the Pullman. In addition to the troop trains, this same route saw train after train heavily laden with ammunition, supplies, and equipment. (Martyn J. Hodes photograph, Paul C. Koehler Collection.)

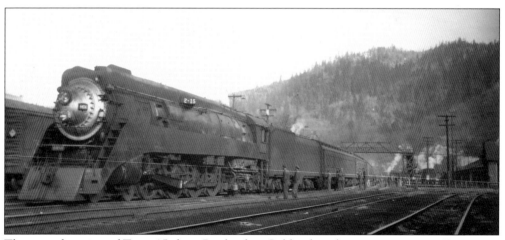

The second section of Train 15, from Portland to Oakland, makes a station stop at Dunsmuir, with quite a few passengers, including some soldiers, taking the opportunity to stretch their legs. Busy wartime traffic saw many scheduled trains running in multiple sections. Second 15 rates a GS-4 in the black associated with this route. (Martyn J. Hodes photograph, Paul C. Koehler Collection.)

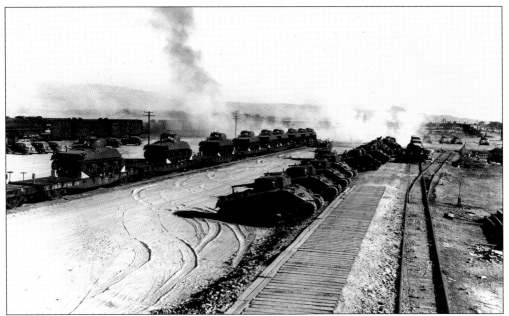

Before Operation Torch, the invasion of North Africa, and the later invasions of Sicily, Italy, and France, the U.S. Army opened its desert training center on vast tracts of federal land in Southern California and Arizona. Here Sherman M4 tanks are being unloaded at Indio, probably in 1942. It is not inconceivable they could have been used to train George Patton's 3rd Armored Division. (U.S. Army photograph, Paul C. Koehler Collection.)

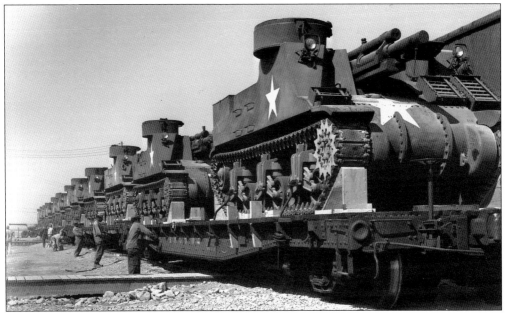

Fatigue-clad soldiers tie M7 105-mm self-propelled howitzers down to a string of flatcars at a training base in the desert. The M7 was a marriage of an M3 tank chassis and an M2A1 howitzer. The weapon first saw use with the British army at the battle of El Alamein in North Africa. The M7s and similar M3 tanks had Continental 9-cylinder radial aircraft engines and were gasoline-fueled. (U.S. Army photograph, Paul C. Koehler Collection.)

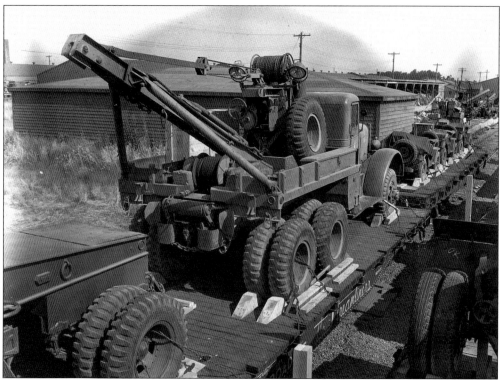

One of the most surprising things about World War II—certainly astonishing to America's enemies—is how quickly the United States was able to produce and ship a vast array of military equipment and supplies. In this photograph, the 6-by-6 in the foreground is fitted out with heavy lifting equipment while the flatcar in front of it has jeeps and another truck—all probably one division's fighting gear. (U.S. Army photograph, Paul C. Koehler Collection.)

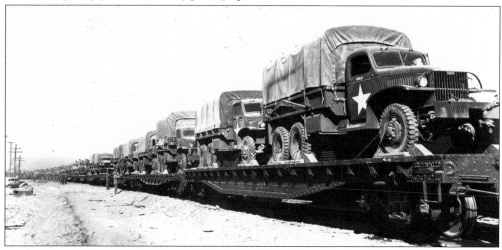

It is hard to tell if these military 2.5-ton (deuce-and-a-half) trucks are coming or going (as military captions could be stingy with information), but it is known railroad flatcars brought thousands of trucks to Indio in World War II and then carried them away to ports of embarkation. It was trucks just like these that formed the Red Ball Express supply convoys in Europe during the war. (U.S. Army photograph, Paul C. Koehler Collection.)

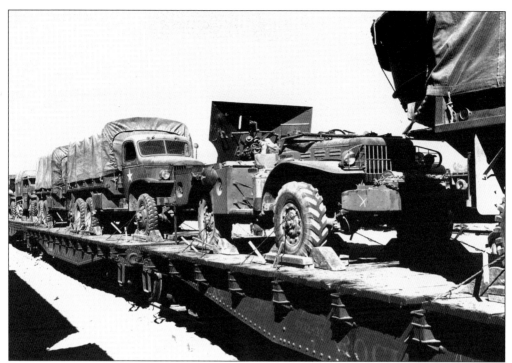

Here military equipment is loaded aboard flatcars at Indio in the early 1940s. There is a gun mount on the 0.75-ton truck and a boat or pontoon in the rear of the truck to the right. Equipment is tied down to the rail cars in a prescribed manner. The army had whole books of regulations detailing precisely how its jeeps, tanks, trucks, artillery, and so forth were to be secured for rail shipment. (U.S. Army photograph, Paul C. Koehler Collection.)

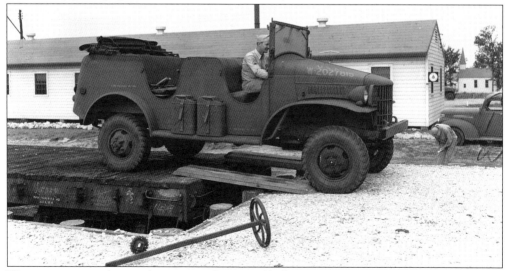

The army sergeant driving this personnel carrier off a flatcar at Camp Beale in Central California is dressed way too well and grinning way too much for this to be anything but a staged photo. The grunt in fatigues looks much more like he is actually working. Flatcar brake wheels and staffs were removable for circus-style loading and unloading. (U.S. Army photograph, Paul C. Koehler Collection.)

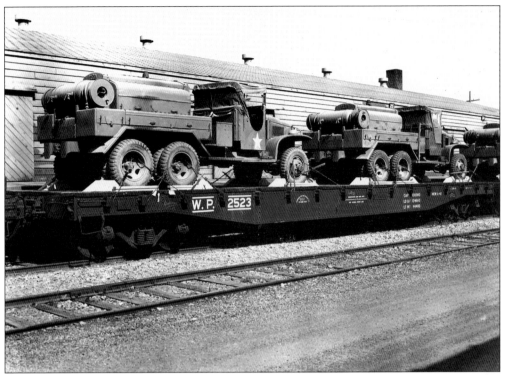

These open-cabbed trucks have been fitted with tanks and hose reels. It is not unreasonable to assume they were part of the support equipment for one of the many armored divisions that trained in the desert in the 1940s. The many types of divisional equipment usually shipped out in one or more trains with a variety of loads. Loads of one type were usually intended for supply depots. (U.S. Army photograph, Paul C. Koehler Collection.)

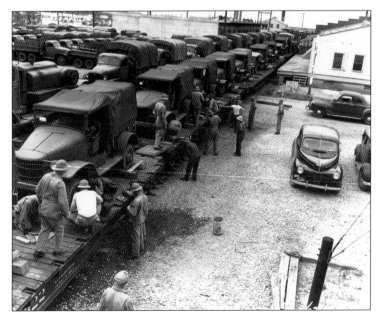

Soldiers are busy tying down Dodge three-quarter-ton trucks belonging to the 772 Tank Destroyer Battalion. It is a good bet the guys with their hands on their hips are sergeants. The building at rear is in the style generations of GIs called "splinter Gothic." The buildings were designed to be temporary but actually lasted through the Vietnam War. (U.S. Army photograph, Paul C. Koehler Collection.)

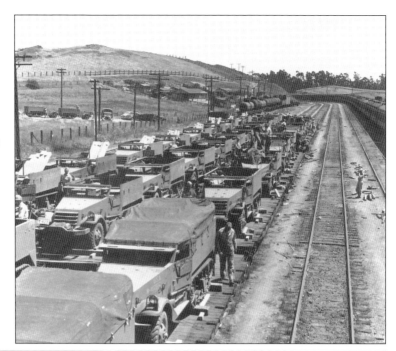

Half-tracks, and lots of them, are loaded on flats at Camp Beale. The tracks were used as gun and troop carriers and served equally well in desert sand or Pacific mud. They were often used, by both the German and American armies, in conjunction with tanks as infantry transports to form a fast-moving and powerful shock unit, or blitzkrieg. (U.S. Army photograph, Paul C. Koehler Collection.)

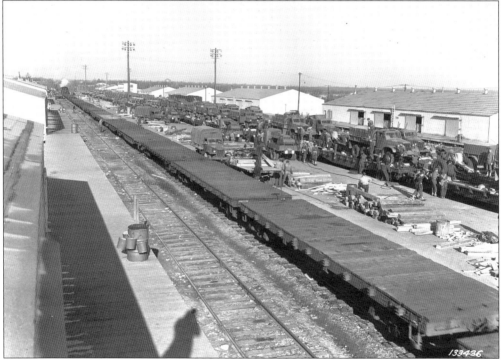

This U.S. Army Signal Corps photograph was taken on December 18, 1941, just days after the Japanese attacked Pearl Harbor and Congress declared war on Japan. The U.S. Army and the Southern Pacific both moved quickly. As soldiers work on two long strings of loaded flats, a switch engine, its plume of steam visible at left rear, moves another string of flats into position. (U.S. Army photograph, Paul C. Koehler Collection.)

The war taxed the capacity of the railroads to the limit. Heavy trains were the norm. Maintenance and locomotive availability were problematic. An overburdened engine has stalled with its long Military Main train coming across the Los Angeles River, pulling into Union Station, just past Southern Pacific's Los Angeles General Shops. (Paul C. Koehler Collection.)

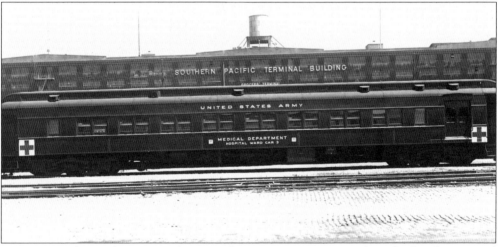

A U.S. Army hospital car sits in the east side SP's San Francisco yard at Third and Townsend Streets during the Second World War. Thousands of wounded soldiers, sailors, and marines were treated at Letterman General Hospital at the Presidio of San Francisco during the war. The window arrangement suggests Hospital Ward Car 3 was converted from a Pullman 16-section tourist sleeper. (Paul C. Koehler Collection.)

Seven
"MEN AT WORK" ON THE SOUTHERN PACIFIC

On October 30, 1949, engines 565, an 0-6-0 T; 1720, a 2-6-0 Mogul; and 4312, a Mountain, were all inside the Southern Pacific's Lamar Street roundhouse in Los Angeles. Developed over years of steam railroading, roundhouses were simply "form follows function" engineering, the best way to service and turn a steam locomotive. They were rapidly torn down after diesels replaced steam. (Paul C. Koehler Collection.)

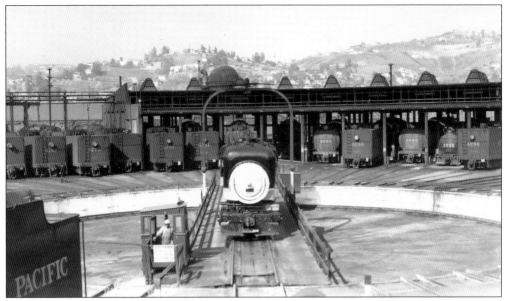

Mt. Washington lies in the background as the camera looks east toward Glendale in this view of the Taylor Yard roundhouse in Los Angeles. Shop switcher 567, an 0-6-0T, sits on the turntable. The Taylor roundhouse served Southern Pacific's freight locomotives. Nine of the engines on the garden tracks are AC-class articulateds—heavy power. (Paul C. Koehler Collection.)

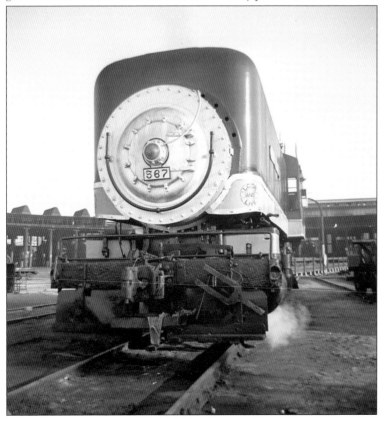

Diminutive yard goat No. 567, like its sibling No. 565 at the Lamar Street roundhouse, has been modified from a standard 0-6-0 switcher into a more compact form by having its water tank wrapped around the boiler. The short length enabled the goat to occupy the turntable with a dead full-sized road engine and move it about the shop area for repair and maintenance. (Don Ball photo, author collection.)

94

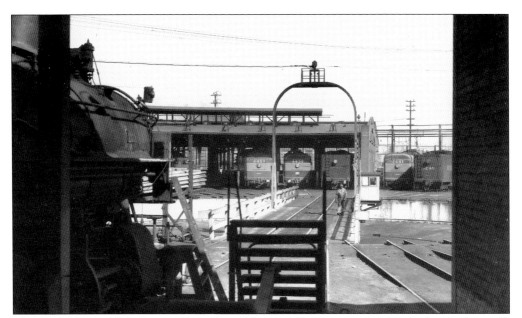

The Lamar Street Taylor turntable is aligned for an AC-class articulated to back out of its stall, be turned, and sent out to the engine service and ready tracks. The big cab forward is flanked left and right by Daylight-painted GS-4 and GS-5 engines, all part of the Los Angeles passenger pool. The view is looking north, and the date was November 6, 1949. (Paul C. Koehler Collection.)

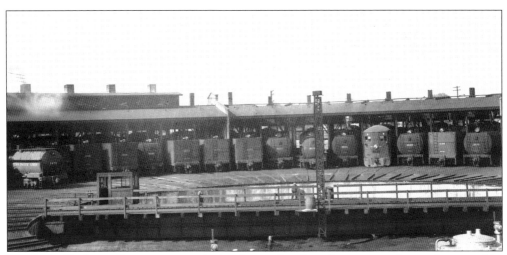

The Taylor Yard roundhouse is jam-packed with articulateds in this view—at least eight are visible. The million-pound monsters roamed the mainlines of the Southern Pacific system hauling freight and passengers. A single example was saved from the scrapper's torch. AC-12 4294 is on display at the California State Railroad Museum in Sacramento. (Paul C. Koehler Collection.)

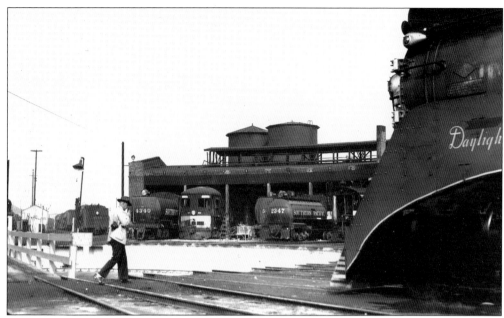

The Southern Pacific's Los Angeles General Shops Lamar Street roundhouse served the railroad's passenger power. The photograph is dated April 24, 1949, and the view is looking east at the ready tracks. Even without the date, there is a clue this photograph was taken around 1950: the chrome stripes are still on the GS-class locomotive's pilot; they were removed later to lower maintenance costs. (Paul C. Koehler Collection.)

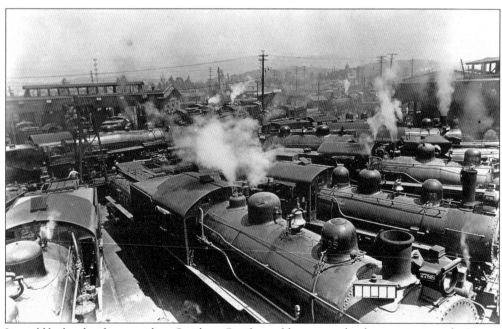

It would be hard to figure out how Southern Pacific could cram another locomotive into the Lamar Street roundhouse. The occasion was a brief strike by the Brotherhood of Locomotive Engineers that was settled July 12, 1947, after negotiations in San Francisco. The strike had idled about a third of the railroad capacity in the western United States. (Paul C. Koehler Collection.)

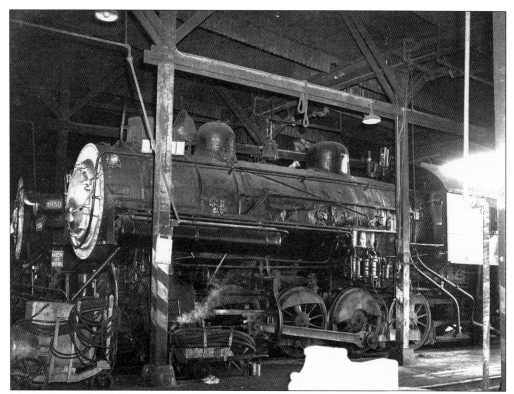

Blue "Men at Work" flags on either side of Consolidation 2850 mandate that it not be moved until the flags are removed. Roundhouses were famously dark and smoky, with heavy equipment used to work on heavy locomotive parts. It was essential that workplace safety rules be followed to the letter. Even so, work-related injuries, even deaths, were all too common. (Paul C. Koehler Collection.)

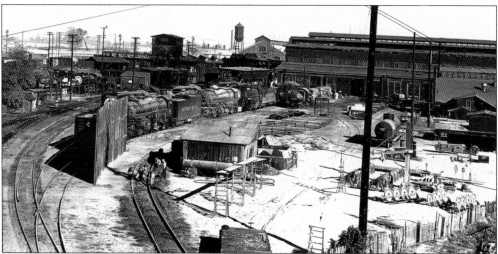

Now part of the California State Railroad Museum, Southern Pacific Railroad's Sacramento General Shops were the place where locomotives and passenger and freight cars went for general overhaul. Some classes of SP locomotives were built here from the ground up. Well into the 1950s, it was common for railroads to build their own rolling stock, and shops like this one were where they did it. (Paul C. Koehler Collection.)

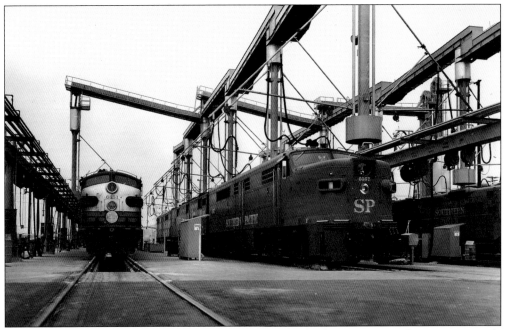

Southern Pacific's Taylor yard diesel refueling and service facility in Los Angeles was commonly called Cape Canaveral because of its towers and gantries. The F-units at left are in SP's famed Black Widow scheme, used for freight locomotives, while the Alco PA units carry the gray and red Bloody Nose scheme that replaced Daylight livery on passenger units starting in 1958. (Paul C. Koehler Collection.)

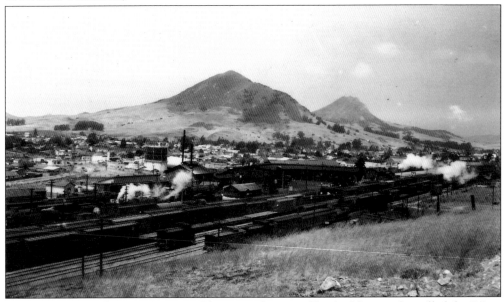

The yard and roundhouse at San Luis Obispo are dominated by the Morros, also called the "Nine Sisters of San Luis Obispo" because there are nine major ancient volcanic peaks in close proximity marching in line from the city to Morro Bay. The yard itself has a Maintenance of Way train in near middle, and there are a number of outside-braced wood boxcars in the photograph. (Paul C. Koehler Collection.)

Hats and suits were on hand in abundance in July 1947 when a new Harbor Belt Line (HBL) yard was dedicated in San Pedro. The HBL was created in 1929 to provide equal Los Angeles Harbor access for the Pacific Electric, Southern Pacific, Union Pacific, and Santa Fe. San Pedro's city hall is in the center background, while the PE depot lurks behind the switcher at right. (Paul C. Koehler Collection.)

There is a lot to see in this view of the Harbor Belt's San Pedro yard, with the San Pedro Hills in the left background. A brakeman is riding the car at near right, a practice long since banned. A wharf shed is at the center rear under the water tank, and the gantry cranes of a shipyard are to the left rear. The Pacific Electric was the big loser in the Harbor Belt agreement. Half its harbor traffic evaporated. (Paul C. Koehler Collection.)

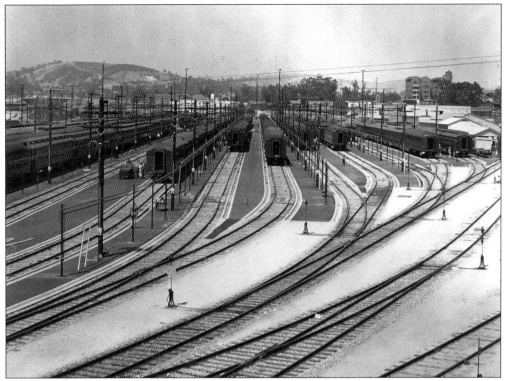

It is early in the 1950s, and the scene is the sprawling Mission Road coach yard in Los Angeles. Although the yard serves Los Angeles Union Passenger Terminal, none of the fabled cars from the luxury, streamlined trains of the era is in evidence. In just a few years, Walter O'Malley will build Dodger Stadium on the hill in the left background, and Branch Rickey will move the Giants to San Francisco. (Paul C. Koehler Collection.)

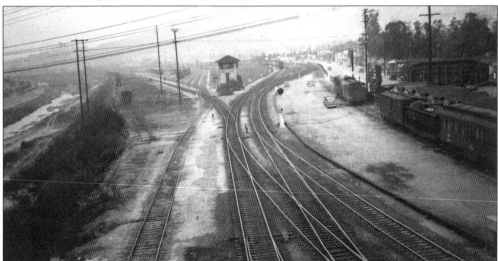

Dayton Tower, at the Taylor Yard throat, is looking rather forlorn, all alone at the south end of the yard. San Fernando Road is to the right of the yard, and the mighty Los Angeles River is still unchanneled, dating this photograph to before 1938. Neither the Figueroa Street nor the Highway Five Overpasses are yet in place. (Paul C. Koehler Collection.)

Enginemen service and board their locomotives at the Taylor Yard ready tracks in 1941. Like all railroads, SP had an Extra Board, with plum assignments such as the passenger trains and timetable freights going to engineers and firemen with the greatest seniority. Way freights, locals, and extras came next, along with yard jobs. (Donald R. Latham photograph, courtesy Dick and Leeanne Curts.)

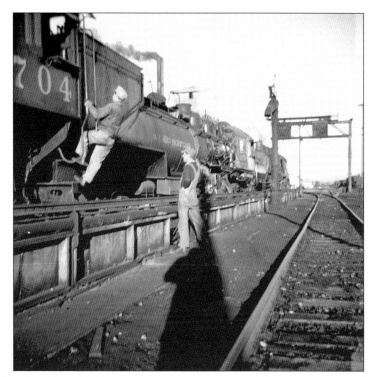

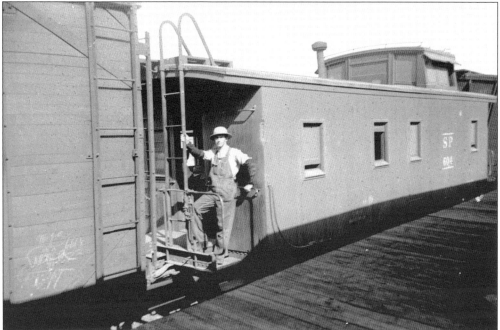

Brakeman Marvin Galloway is looking dapper in a pith helmet on the veranda of caboose 604. Marvin was an avid photographer, but he also liked to have friends take pictures of him. From another of Marvin's photographs, it can be surmised that this photograph was taken at the freight station in Calexico in 1941. Marvin was 26. (Marvin R. Galloway collection, courtesy Dick and Leeanne Curts.)

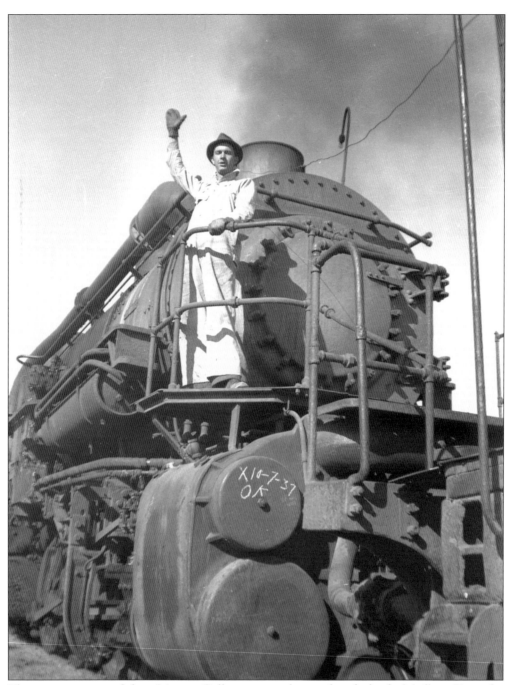

This time sporting a fedora, Marvin Galloway is on the monkey deck of a Mudhen. From the markings on the cylinder, the year is likely to be 1937, possibly on SP's Modoc line, where the locomotives worked in substantial numbers perhaps because there were few people there to see them. The Mudhens were ungainly critters, SP's earliest cab forward articulated locomotives, with a drop-off deck and no air pumps on the smokebox front. Longtime Southern Pacific engineman Vince Cipolla said he hated their rounded "whale back" tenders, fearing he would fall off while watering or fueling. (Marvin R. Galloway collection, courtesy Dick and Leeanne Curts.)

Brakeman Byron K. Mobley rides a string of Pacific Fruit Express (PFE) refrigerator cars. The cars are equipped with patent Bohn ventilators, which supposedly aided the flow of fresh air in the cars. PFE removed them by the early 1940s on the grounds that the initial added expense and continuing maintenance costs were not justified. (Marvin R. Galloway photograph, courtesy Dick and Leeanne Curts.)

Unfortunately, photographer Donald Latham did not record the name of this young man, dapper in his freshly-laundered Oshkosh overalls, engineer's cap jauntily perched, gloves, and protective gaiters over his work shirt. Certainly, he seems a bit young to have been called to be the engineer or fireman of the 10-coupled locomotive behind him. Perhaps he was the head-end brakeman. (Donald R. Latham photograph, courtesy Dick and Leeanne Curts.)

We do not know this gentleman's name, or whether he is the owner of that shiny Ford in the Taylor Yard employee parking lot, but the covered vehicle in the rear tells us how train crews kept their cars clean amid all the smoke from oil-fired engines. Paying for the cars is another story. In the late 1930s, Southern California industries were producing, and the railroad was hauling, goods for the war in Europe. (Donald R. Latham photograph, courtesy Dick and Leeanne Curts.)

This unidentified gentleman is the picture of patience as he waits in Taylor Yard for his train to pick him up. If he were an engineman, he would already have picked up his train, so it is a good bet he is the conductor. Conductors were essentially traveling business managers for freight trains, keeping track of all the paperwork as cars were picked up and delivered so shippers could be properly billed. (Donald R. Latham photograph, courtesy Dick and Leeanne Curts.)

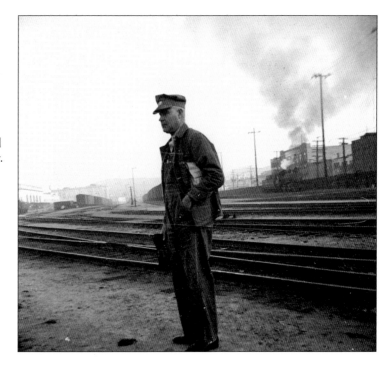

H. O. Mullen is standing on the fireman's side of cab forward 4197 in this snapshot taken at the Taylor roundhouse in 1941. The photograph gives us an appreciation of just how big these Articulated Consolidations really were. Nothing on modern railroads approaches them in size, weight, or per-unit horsepower. (Donald R. Latham photograph, courtesy Dick and Leeanne Curts.)

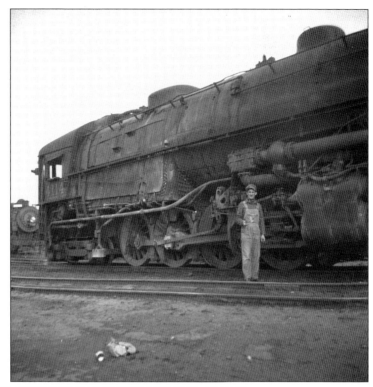

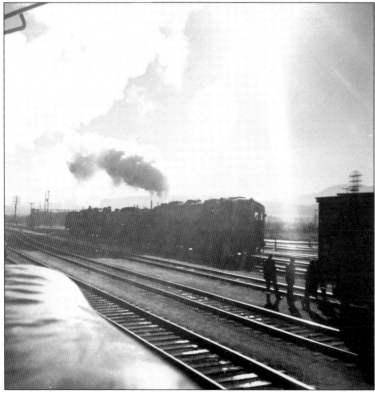

Most new photographers are told to never shoot into the sun. Donald Latham ignored that advice while on the job at Taylor Yard in 1942 and was rewarded with this dramatically backlit shot of a cab forward and a helper, either just cut off or backing down to their train. (Donald R. Latham photograph, courtesy Dick and Leeanne Curts.)

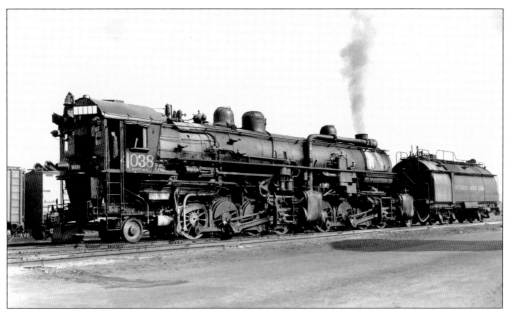

Here in all its glory is the Mudhen, probably the ugliest American locomotive ever made. Southern Pacific's cab forwards were essentially backwards Yellowstones, 2-8-8-4 articulateds first built for the Northern Pacific and also rostered by the Duluth, Missabee and Iron Range, the Baltimore and Ohio, and SP itself in the AC-9. All those were handsome engines, and SP eventually got its cab forwards looking pretty good. (Donald R. Latham photograph, courtesy Dick and Leeanne Curts.)

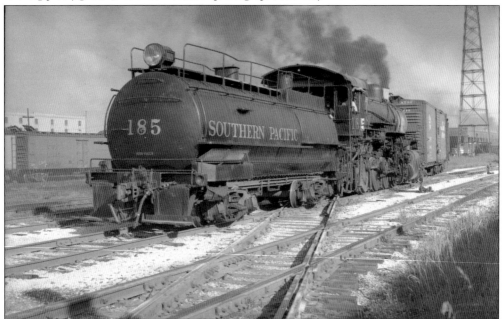

This Southern Pacific switch engine is shoving a Santa Fe boxcar, a rebuild of an earlier wood-sheathed, outside-braced United States Railroad Association (USRA) car to more modern all-steel construction. The railroads were avid recyclers long before its current mode. Nor did they hesitate to drastically rebuild locomotives. Santa Fe famously converted 2-10-10-2 articulateds into much more efficient 2-10-2s. (Don Ball photograph, author collection.)

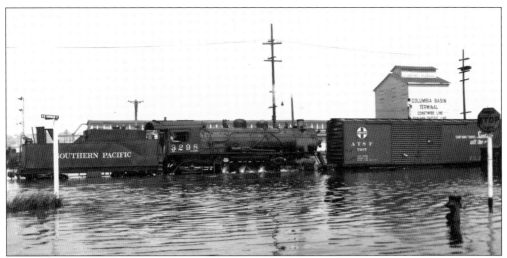

There are some places a steam engine can go where no diesel dares tread. The floodwater comes up to the engine's cylinders and is almost over the freight car's wheels—all told, about 3 feet above the top of the rails. The image can be roughly dated by identifying the Santa Fe freight car as a Fe-22, a class built in 1941. (Paul C. Koehler Collection.)

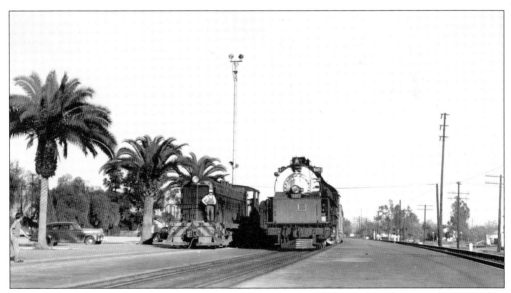

Donald R. Latham is the fireman on the Baldwin diesel at right in this photograph snapped in Alhambra some time in 1946. At right is a GS-1 with an unusual shield over its air pumps. The diesel might be one of the early 1,000-horsepower models, with four individual stacks poking through the engine's hood. Baldwin diesels were well received by the Southern Pacific. (F. E. Lionberger photograph, courtesy Dick and Leeanne Curts.)

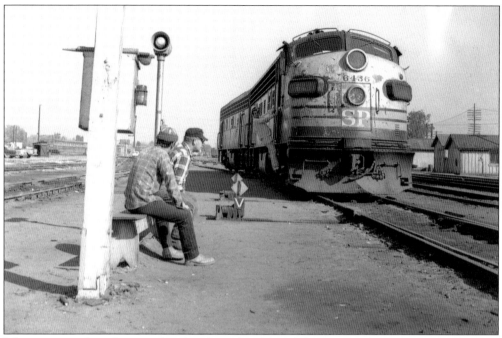

Like service in the military, railroading has a fair share of "hurry up and wait." Fortunately, there is a bench for the crew of F-unit 6436, wearing bedraggled Black Widow paint. Unlike spit-and-polish Santa Fe, which kept its motive power clean and shiny as a form of corporate advertising, SP never met the freight locomotive it would not let look like hell. (Don Ball photograph, author collection.)

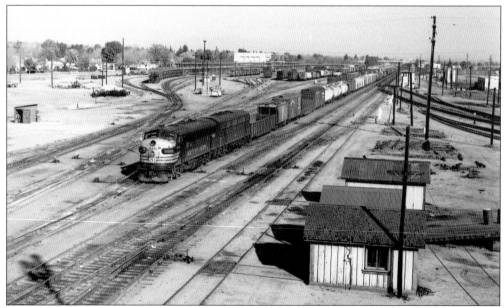

Extra 6436 finally got its "highball," and the crew has it rolling out of Fresno with a long string of boxcars, tank cars, and hoppers trailing behind. The two units add up to 3,000 horsepower, enough to move a loaded train up the San Joaquin Valley. There is a very large ice dock at left served by two tracks, a sure sign of an agricultural area. (Don Ball photograph, author collection.)

Eight
"All Aboard!": From Union Stations to Whistlestops

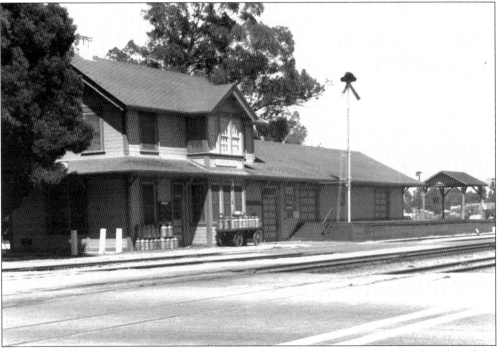

The tree-shaded Southern Pacific depot is long gone from Northridge, although it lasted until the 1950s. At the time this photograph was taken, the depot supported local dairies with rail service to carry the milk to market. The evidence is the baggage cart stacked with milk cans along with another stack to the cart's left. The milk cans were transported in 60-foot Harriman baggage cars. The cars were unrefrigerated, so the market or dairy company plant had to be close by, in this case Los Angeles, but it would not have been unreasonable for the cans to go directly to a bakery. (Paul C. Koehler Collection.)

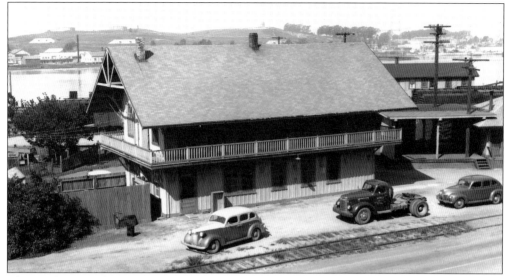

The Southern Pacific station at Vallejo was a handsome structure with a view of the water. It was of board and batten construction, with a full second story and verandas shielded by wide roof overhangs. A separate freight station is to the right. The second floor of the station provided living quarters for the stationmaster and probably additional office space. (Paul C. Koehler Collection.)

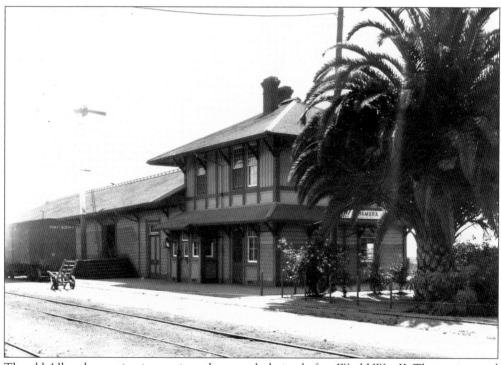

The old Alhambra station is seen in a photograph dating before World War II. The station, and the big palm tree, were knocked down in the early 1970s and replaced by a Spanish mission–style structure not all that long before the end of passenger service on the Southern Pacific. The SP wooden stations were built to several different common standards but frequently modified to fit local needs. (Paul C. Koehler Collection.)

The Lone Pine station was about as far as the Southern Pacific's Jawbone branch got into the Owens Valley, although the tracks continued a short distance for the interchange with the narrow gauge at Owenyo. The van is a 24-foot Autocar with converter gear in the foreground to allow a second trailer to be hitched behind the tractor. The trucks picked up local cargo for transfer to boxcars. (Paul C. Koehler Collection.)

The freight depot and yard office at Calexico was a lonely place when Marvin Galloway climbed atop a freight car and snapped its portrait in 1941. The depot has a very long and wide freight platform, not at all typical of Southern Pacific practice. Calexico is at the bottom end of the Imperial Valley and was an important source for agricultural traffic as well as a connection to Mexican railroads. (Marvin R. Galloway photograph, courtesy Dick and Leeanne Curts.)

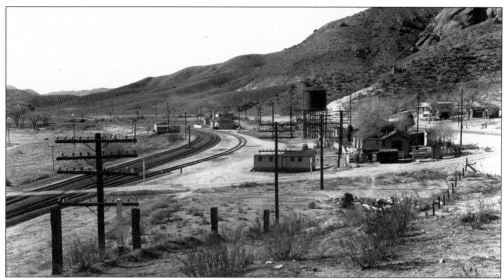

Ravenna, in once lonely but now developed Soledad Canyon east of Los Angeles, is near where the gold spike was driven at Lang upon completion of Southern Pacific's San Joaquin line in 1876. Ravenna once had the station seen here, a water tank, and a few cabins for the track workers who maintained the line. Everything in the photographs is now gone except the tracks. (Milt Harker photograph.)

It is hard to believe how something as common and utilitarian as a railroad water tank can have a timeless grace and dignity. Tanks much like this SP common standard 65,000-gallon water tank located at Acton, California, in Soledad Canyon, were essential to the operation of steam engines. In fact, they gave rise to the term "tank towns," from the communities that grew up around the water tanks. (Paul C. Koehler Collection.)

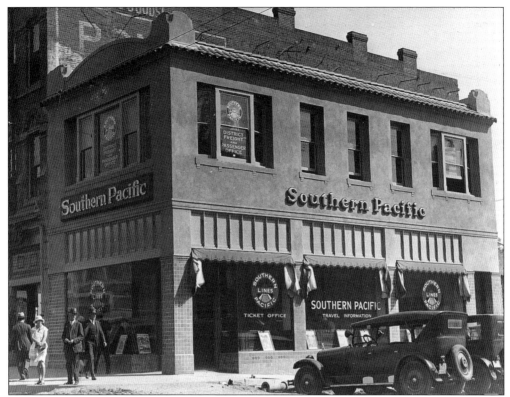

Pasadena is known for its mission-style Santa Fe passenger station, but the city also had a Southern Pacific passenger and freight office, with at least a nod toward mission style. SP's office sat on what is now some very high-priced real estate, at the corner of Colorado Boulevard and Arroyo Parkway. One interesting thing in this 1920s photograph is that the street does not appear to be paved. (Paul C. Koehler Collection.)

The Glendale station was the first stop from Los Angeles Union Passenger Terminal for the *Coast Daylight* and *Lark* heading towards San Francisco along the Coast Line. The *San Joaquin Daylight* and the *Owl* also stopped here. The station is the closest to Hollywood and Beverly Hills. Movie stars wishing to avoid the press would get off here (although often making sure their press agents notified the papers). (Paul C. Koehler Collection.)

Getting the railroads to agree on the need and the location of a union station was difficult. For years, they each operated independent stations. Southern Pacific's station was a grand affair, at Fifth and Central Streets, and was known as Central Station. In this view from around 1910, (above) cars and also horse-drawn wagons are in the left rear, and streetcar tracks are being dug into the roadway at far left center. The station's lobby (below) had the spacious architecture typical of the major stations of the era. Incidentally, people at that time dressed quite well when they undertook such an adventure as traveling. (Paul C. Koehler Collection.)

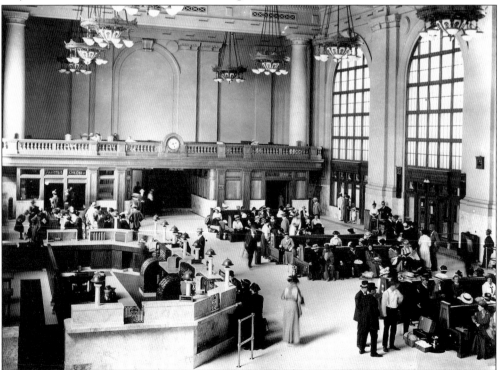

114

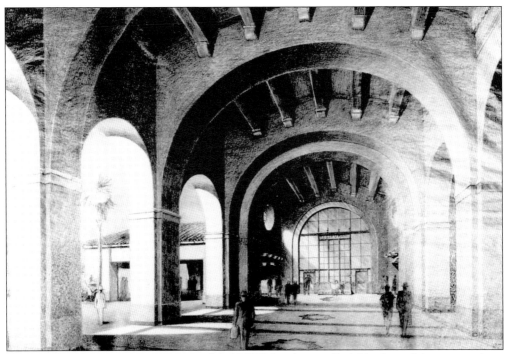

Los Angeles Union Passenger Terminal (LAUPT) has been called "the last of the great railway stations." It opened in 1939, as the railroads were ushering in their colorful new streamlined trains. An architect's rendering below shows the portico linking the arrivals hall to the Fred Harvey restaurant. The drawing above shows the entrance to the station restaurant, itself designed by noted Southwestern architect Mary Colter. The restaurant was the last Harvey House to be designed as part of a station. The restaurant's waiting area can be seen as the police station in the movie *Blade Runner*, set in the Los Angeles of 2019. (Paul C. Koehler Collection.)

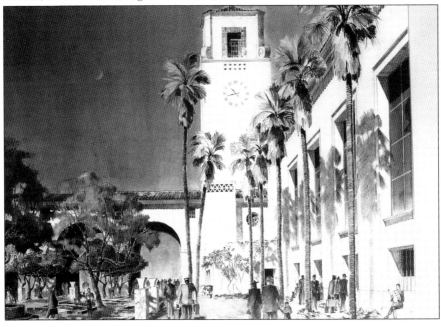

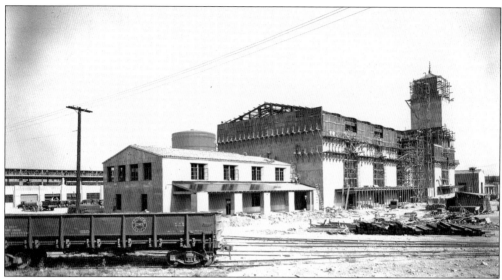

In this photograph, taken from the corner of Alameda and Macy Streets, construction of LAUPT's main building is well underway. The station was built to simultaneously serve the Southern Pacific Railroad, the Atchison, Topeka and Santa Fe Railway, the Union Pacific Railroad, the Pacific Electric Railway, and the Los Angeles Railway. The latter was the city's narrow gauge streetcar line. (Paul C. Koehler Collection.)

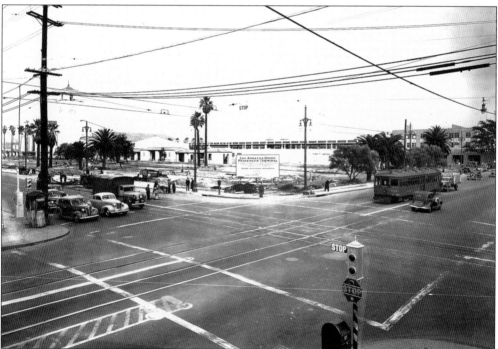

LAUPT is in its final construction phase in this photograph looking northeast at the intersection of Alameda and Aliso Streets. All that remains is the landscaping and paving the parking lot. Pacific Electric streetcar 634 is one of PE's famed Hollywood cars, and the traffic signal at the corner is one of the old stop-and-go type, with moveable arms and just two colored lights. (Paul C. Koehler Collection.)

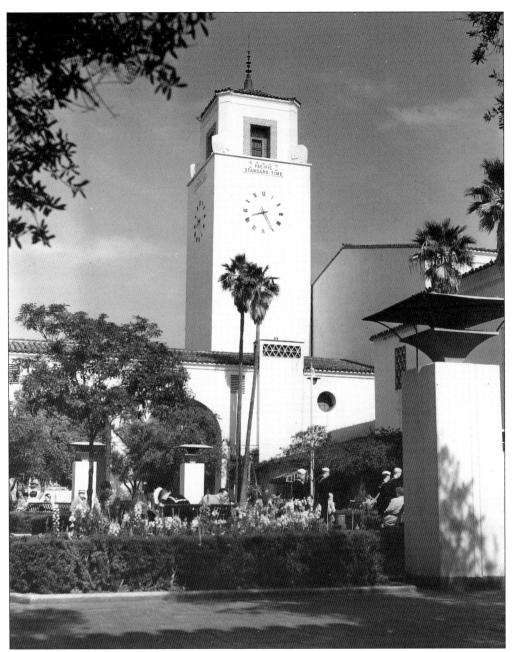

The station is open in this photograph, taken from the north side of Alameda Street, with the garden outside the station restaurant fully landscaped and apparently offering meals affordable to sailors. The handsome station shows its graceful blend of Mission Revival, Dutch Colonial Revival, and Streamline Moderne architectural styles. The terminal will soon get much busier as World War II's record-setting travel looms. Traffic will decline in the 1960s and 1970s then pick up again in the 1990s and the early 21st century, with booming commuter and light rail traffic as well as a busy Amtrak schedule. Regrettably, the station cannot be clearly seen from directly across Alameda today. An office building has been built in the parking lot. (Paul C. Koehler Collection.)

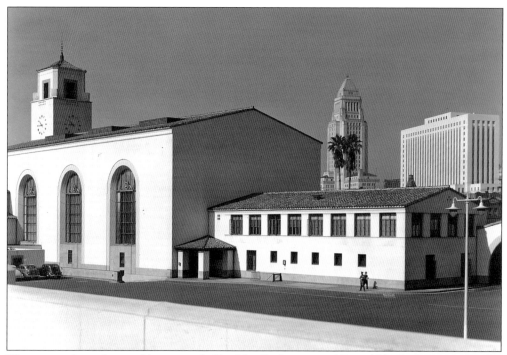

The terminal was designed by a team led by John Parkinson and Donald B. Parkinson, who also designed the Los Angeles City Hall, seen behind the terminal in the photograph above. The image below shows LAUPT as seen from Los Angeles City Hall, on a remarkably clear day, sometime before the Hollywood Freeway was built. The big building in the central background is the Los Angeles County General Hospital/University of Southern California School of Medicine. The buildings at left above the depot are the SP's L.A. General Shops. The big black tank in the right center background is one of the expandable natural gas tanks so common to the L.A. skyline until about the mid-1960s. (Paul C. Koehler Collection.)

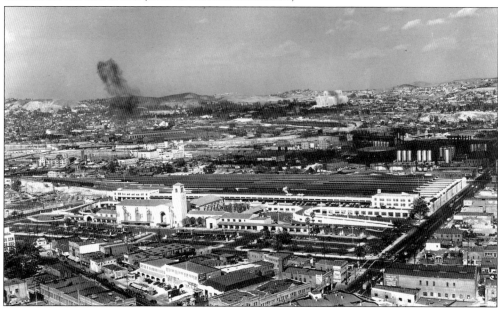

Nine
WRECKS, RESCUES, AND THE SCRAPPER'S TORCH

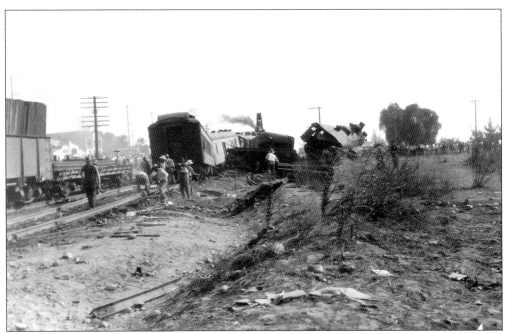

The crew of the Los Angeles wreck crane works to lift Mountain 4351 back onto the tracks after the southbound *Lark* struck a truck and derailed in Glendale on October 20, 1935. The train's engineer and fireman were injured, along with ten passengers. Several other passengers in the Pullman cars were severely shaken. The truck driver jumped to safety before the collision. The accident happened at Aviation Drive near the southeast end of Grand Central Air Terminal, where the Southern Pacific's tracks parallel San Fernando Road, and only a short distance from the Glendale passenger station. (Paul C. Koehler Collection.)

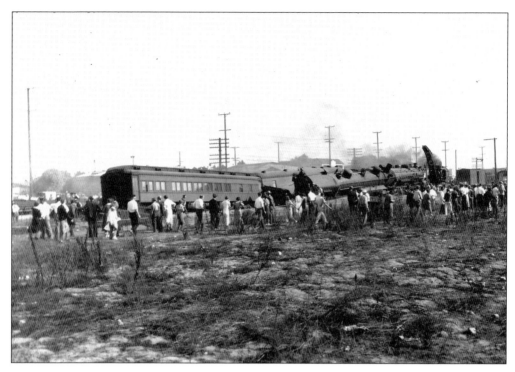

Both locomotives pulling the 16-car *Lark* derailed in the wreck and plowed an 800-foot furrow alongside the tracks before rolling partway over. Engineer Arthur Champlin and fireman Oland Colwell were thrown from the plunging lead locomotive. The train, with more than 170 passengers aboard, was a half-hour from its Los Angeles destination after an overnight journey from San Francisco. The *Los Angeles Times* reported that Dr. Rufus B. VonKleinschmidt, the president of the University of Southern California, was briefly knocked unconscious. The paper also said that spilling coffee burned every member of the kitchen crew in the diner. (Paul C. Koehler Collection.)

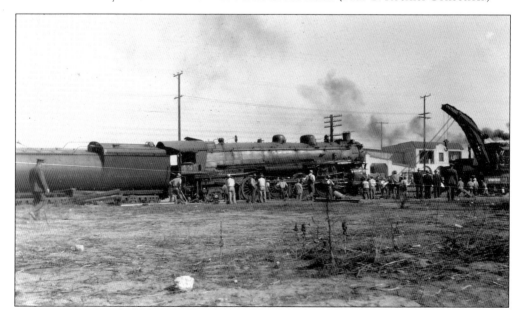

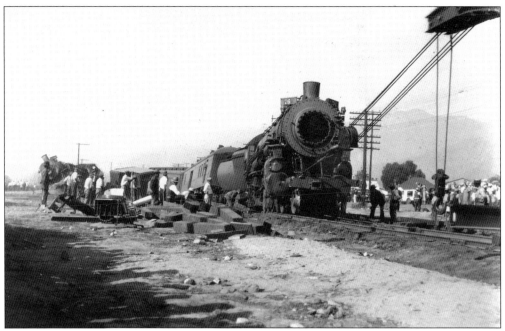

Cables from the "Big Hook" are tied into the frame of the lead engine. Wreck crews were always on standby and responded as quickly as possible to accidents. Their heavy equipment was often essential to rescue victims of a crash. The railroad also wanted to remove damaged rolling stock and restore the tracks to operation. (Paul C. Koehler Collection.)

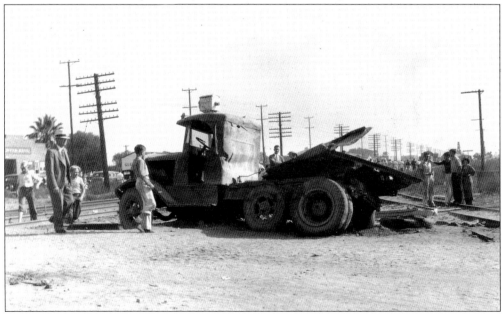

Collisions were always a danger where roadways crossed railroad tracks. When built, the railroad's only competition for the right-of-way was the horse, but by the second decade of the 20th century, motor vehicle–train collisions were increasingly common. In the 1932 Glendale accident, truck driver E. J. Chaney was hauling seven tons of sand when he got stuck on the tracks. (Paul C. Koehler Collection.)

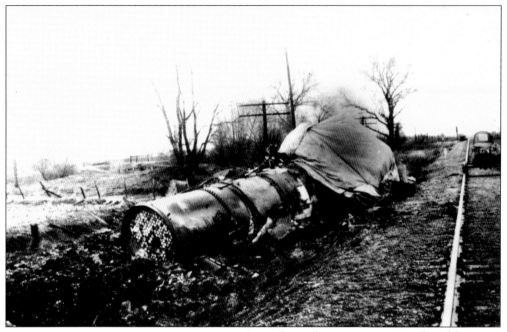

Steam locomotives were vulnerable to an accident less common but far more deadly than road-crossing collisions. If the engine crew allowed the water in the boiler to get too low, the crown sheet, the piece of steel across the top of the firebox, would become exposed and crack. The failure allowed the boiler and fire tubes (left) to almost instantly depressurize, vaporizing the boiling water into steam in a powerful explosion. Locomotives were built with safety valves and gauges, which the crew ignored at their peril. Faulty construction, flawed or corroded firebox steel, and poor maintenance also were possible causes of a crown sheet explosion. (Paul C. Koehler Collection.)

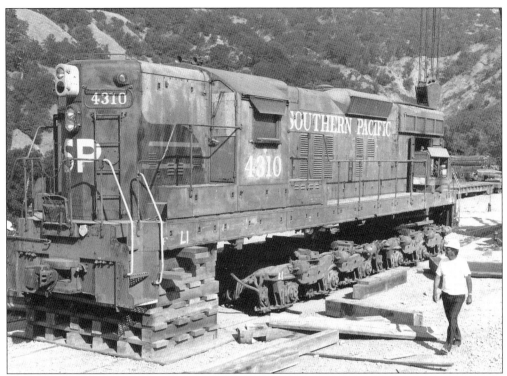

All too often, torrential rains would wash out a portion of the Northwestern Pacific's line up the Eel River Canyon between Willits and Eureka. The 4310 is one of a set of SD-9s isolated by a washout. The SP hauled them out to live track. The engine's trucks were removed before lifting the locomotive to a low-boy dolly (above). The auxiliary generator on the diesel's walkway works the dolly's airbrakes. Below, the 4310 gets underway. The problem with a move like this is not so much getting the 180-ton load moving but getting it stopped. That is why a second tractor is chained behind the rig as a brake sled. The huge weight behind the sled's cab provides extra heft to boost traction when the brakes are applied. (Paul C. Koehler Collection.)

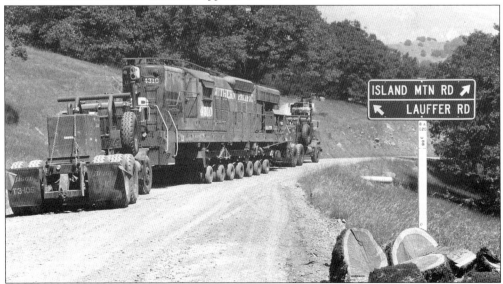

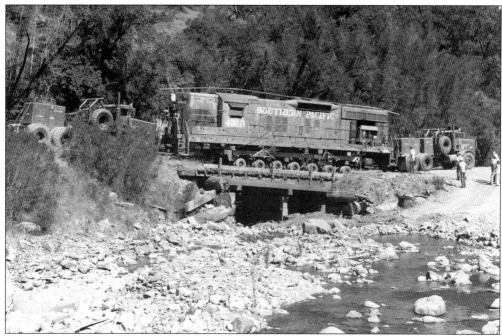

This rescue move was anything but a piece of cake. Above, the bridge over the creek is either temporary or an older, lighter bridge that had to be strengthened to bear the weight of the heavy locomotive and the two tractor units. The lead tractor also has added weight over the drive wheels for increased traction. Below, this could be a picturesque drive down an unpaved back road in wine country except for one minor detail—the behemoth trundling down the road toward the photographer. SP eventually tired of the necessity for rescues like this and sold the line to the Eureka Southern, which went bankrupt in 1992 after a series of El Niño storms washed out much of its trackage. (Paul C. Koehler Collection.)

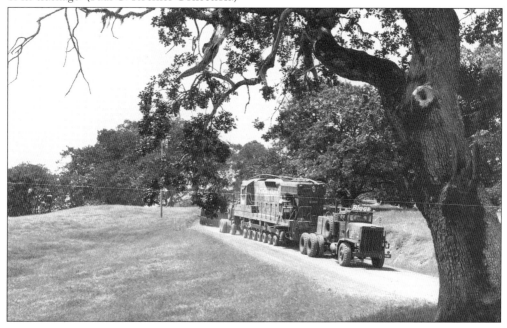

Steam engines are part of the allure of railroading for railfans, but railroads are anything but romantic about the equipment they operate. Money/profit is the object of the game. The fact is steam locomotives were manpower intensive and costly to maintain. Regular inspections, boiler washes, flue replacement, and more were all part of steam's bill. Diesel locomotives did require a greater initial capital outlay, but once the reliability and consequent increased operational availability of diesels was demonstrated, railroads were quick to put their steam power out to pasture. (Don Ball photographs, author collection.)

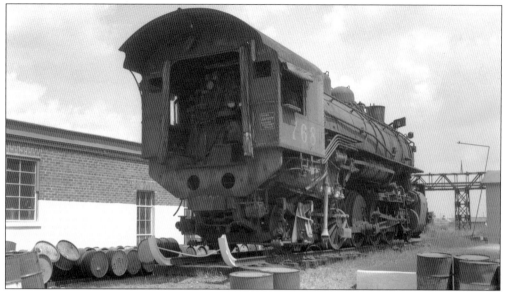

Forlorn and abandoned, Engine 768 is not going anywhere under its own power ever again. Steam power pulled American trains for more than 120 years, an enviable service record by any standard. The 1950s saw the flowering of the new diesel technology in combination with an economic downturn and an increase in scrap steel prices. For steam power, it was a fatal combination. (Don Ball photograph, author collection.)

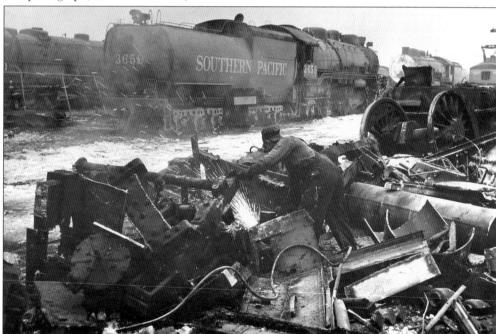

The biggest steam power went first to the scrapper's torch. It was the most expensive for the railroads to operate and maintain, and it had the most steel to sell. Much of the scrap was shipped to Japan, where it was used to build the Hondas, Nissans, and Toyotas that would eventually spell disaster for General Motors, just as GM's EMD diesels spelled the end for steam. (Paul C. Koehler Collection.)

BIBLIOGRAPHY

Ambrose, Stephen E. *Nothing Like It in the World.* New York: Simon and Schuster, 2001.
Bain, David Hayward. *Empire Express, Building the First Transcontinental Railroad.* New York: Penguin Books, 1999.
Ferrell, Mallory Hope. *Southern Pacific Narrow Gauge.* Edmonds, WA: Pacific Fast Mail, 1982.
Hanft, Robert M. *San Diego & Arizona: the Impossible Railroad.* Glendale, CA: Trans-Anglo Books, 1984.
Mullay, Larry, and Bruce Petty. *The Southern Pacific in Los Angeles: 1873–1996.* San Marino, CA: Golden West Books, 2002.
Morris, Joe Dale. *Southern Pacific's Slim Princess in the Sunset: 1940–1960.* Pasadena, CA: Southern Pacific Historical and Technical Society, 2008.
Signor, John R. *Southern Pacific's Coast Line.* Wilton, CA: Signature Press, 1995.
———. *Southern Pacific's Shasta Division.* Wilton, CA: Signature Press, 2000.
———. *Southern Pacific's Western Division.* Wilton, CA: Signature Press, 2003.

www.arcadiapublishing.com

Discover books about the town where you grew up, the cities where your friends and families live, the town where your parents met, or even that retirement spot you've been dreaming about. Our Web site provides history lovers with exclusive deals, advanced notification about new titles, e-mail alerts of author events, and much more.

Arcadia Publishing, the leading local history publisher in the United States, is committed to making history accessible and meaningful through publishing books that celebrate and preserve the heritage of America's people and places. Consistent with our mission to preserve history on a local level, this book was printed in South Carolina on American-made paper and manufactured entirely in the United States.

This book carries the accredited Forest Stewardship Council (FSC) label and is printed on 100 percent FSC-certified paper. Products carrying the FSC label are independently certified to assure consumers that they come from forests that are managed to meet the social, economic, and ecological needs of present and future generations.

FSC
Mixed Sources
Product group from well-managed forests and other controlled sources
Cert no. SW-COC-001530
www.fsc.org
© 1996 Forest Stewardship Council

Find Your Place in History.